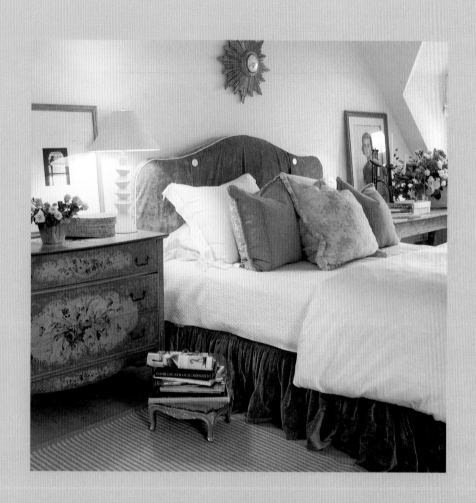

CALIFORNIA
DESIGN LIBRARY

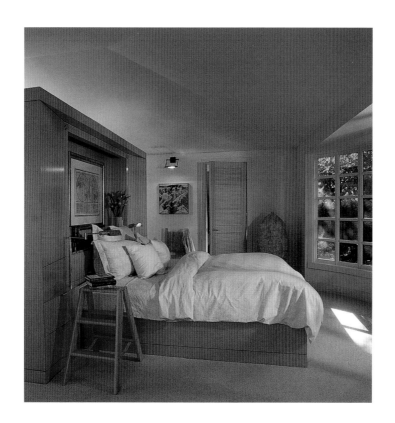

BEDROOMS

Diane Dorrans Saeks

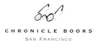

CHRONICLE BOOKS

SAN FRANCISCO

For my son, Justin, with love, always. — D.D.S.

Printed in Hong Kong

Book and Cover Design:
Madeleine Corson Design, San Francisco

Cover Photograph:
A cozy attic bedroom designed by Stephen Shubel.
Photography by Alan Weintraub.

Title Page:
A serene, simple California bedroom with garden views.
Photography by David Livingston.

Library of Congress Cataloging-in-Publication Data available.

ISBN 0-8118-1331-2

Distributed in Canada by:
Raincoast Books
8680 Cambie Street
Vancouver BC V6P 6M9

10 9 8 7 6 5 4 3 2 1

Chronicle Books
85 Second Street
San Francisco
California 94105
Web Site: www.chronbooks.com

CONTENTS

INTRODUCTION 7

STYLE PORTFOLIO

BARBARA BARRY DREAMING IN WHITE IN LOS ANGELES 11

MICHAEL SMITH ANTIQUES AND SILKEN DRAPERIES IN LOS ANGELES 13

STEPHEN SHUBEL A BERKELEY RETREAT WITH SUMMER-COOL COLORS 15

MICHAEL BERMAN A THIRTIES BEDROOM IN THE HOLLYWOOD HILLS 17

KERRY JOYCE A BEDROOM FOR JAMIE GERTZ IN LOS ANGELES 19

KATE MCINTYRE & BRAD HUNTZINGER IRON AND SILK IN SEA CLIFF 21

ANDREW VIRTUE PIED-A-TERRE IN LONG BEACH 23

KATE STAMPS FANTASY BEDROOM IN LOS ANGELES 25

MELISSA WALLACE DEITZ A CHIC BEDROOM IN HOLLYWOOD 27

ARNELLE KASE A TIMELESS BEDROOM IN SAN FRANCISCO 29

DESIGN WORKBOOK

RENOVATING & REMODELING TIPS 33

TIMELESS DESIGN 35

EASY UPDATING 41

DRAPERIES, STORAGE & FLOORS 45

HELP FROM THE PROS 49

BIG IDEAS FOR SMALL ROOMS 59

CHOOSING A GREAT BED 65

A WARDROBE OF SHEETS 71

UP ON DOWN PILLOWS & COMFORTERS 75

COLOR SCHEMES 79

FENG SHUI 83

DIAMONDS IN THE ROUGH 87

THE GRACIOUS GUEST ROOM 93

CHILDREN'S BEDROOMS 97

ACCESSORIES 103

CALIFORNIA CATALOGUE 106

INDEX 118

BEDROOMS ARE FOR DREAMING

California bedrooms, at their best, transcend design and architecture and fulfil the great human need for a retreat, for a place that nurtures daydreaming, for a return to tranquility. And so every page of this book is filled with pragmatic advice and problem solving — balanced with encouragement to create a sanctuary and a private room away from the world. Enthusiastic dreamers and passionate travelers, top interior designers, and architects in California apply their restless imaginations and generous spirits to creating the bedroom as a refuge, so that a third of the day is spent at peace. Whether gifted by their clients with beautifully proportioned and graceful interior architecture, or faced with a bland, boxy bedroom, they cast far and wide in the collective memory for inspiration. Designs from the past always inform California interiors. Sometimes a Gustavian palace ballroom suggests a color scheme. Or a Jean-Michel Frank or Ruhlmann chair, chic and sensuous, is transmuted into a dressing table chair. A Fred Astaire film, a boat ride on Lake Bellagio, a Tuscan afternoon, or a couture collection can all quicken the pulse and offer design inspiration. The best bedrooms have a quiet, timeless quality, a universal poetry. Michael Smith returned from explorations in Paris and fashioned a cosmopolitan bedroom. Barbara Barry insists on Egyptian cotton sheets — white only. Kate Stamps loves four-posters and vintage textiles. Trust your own taste. Trendiness is to be avoided. Bedrooms have a daytime life, too. They should have a cozy armchair near the windows, where escapees from care can snooze like a cat in the late afternoon sun or gaze over the garden or the bay. Everything should be at hand — the slippers and wraps, a simple beeswax candle, a pencil and paper, a CD player, a jolly bunch of garden jonquils. ♀ But most of all, a fine and wonderful bedroom is one in which romance, dreams, and fantasies are but an eyelid's closing away. No intimate detail is too small. The mattress comforts and soothes the body at day's end. In the darkness, sheets gently wrap and protect. Flowers and fragrance freshen the air and uplift the spirit. Sounds fade. ♀ Hush, night falls. The world disappears. The bedroom is transmuted into a place for dreaming. OPPOSITE In Healdsburg, in Northern California, Wade and Myra Hoefer have created their own sweet retreat. They've hidden the handcrafted bed behind favorite objects and flowers, and dressed it with Russian linens. The curved ceiling and muted light give the room a lofty, spiritual feeling.

The wardrobe

is filled with linen

There are even moonbeams

which I can unfold

ANDRÉ BRETON

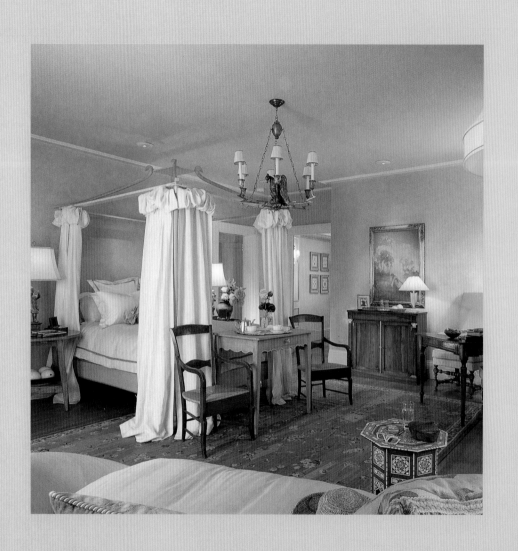

Visionary designers — the best of whom are pragmatists and dreamers — walk into a lackluster bedroom and daydream a new boudoir into existence. They respect the integrity of the interior architecture, or — if there are no "bones" to speak of — immediately take steps to give a room beautiful proportions. Michael Smith envisioned silk draperies with the confidence and grace of a Balenciaga ballgown — in a monastically spare white room. Andrew Virtue played Madeleine Castaing. Stephen Shubel, Kerry Joyce, and Barbara Barry polished bedrooms to perfection — not a color too loud nor a sheet less than pristine. Kate McIntyre and Brad Huntzinger carefully calibrated ethereal color, giving a bedroom grace and charm. The best bedroom design always takes a leap of imagination — and balances romance with a certain discipline and a sense of fun. OPPOSITE A dreamy bedroom by San Francisco designer Joszi Meskan.

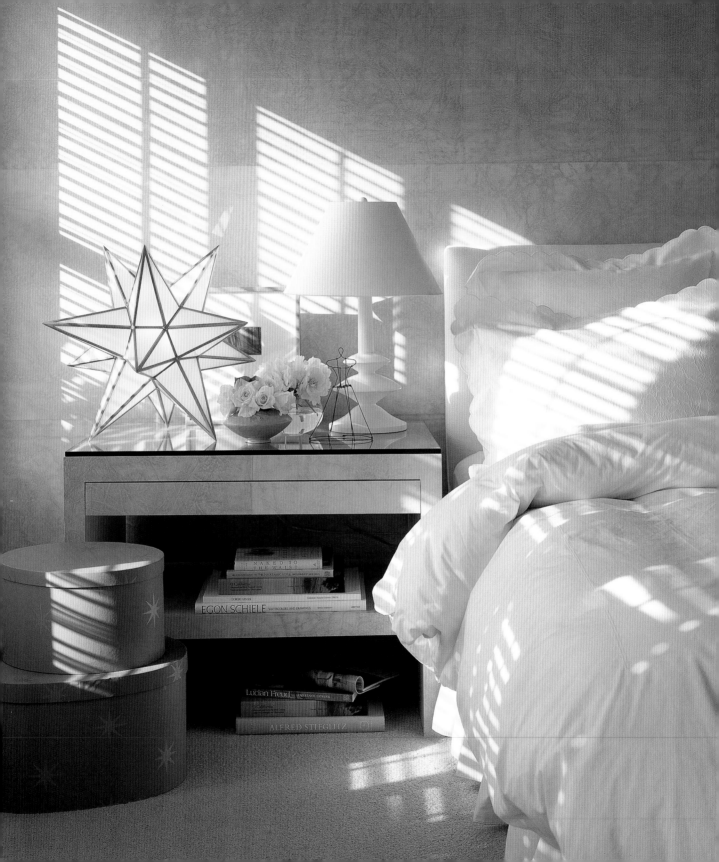

The past seven or eight years must seem like a blur to Los Angeles interior designer Barbara Barry. Not only has she established her own decorating business, she has also introduced a highly successful 40-piece collection of furniture for Baker Furniture, along with chairs for a contract furniture company, lighting for Boyd, rugs for Tufenkian Tibetan Carpets, and a line of fabrics in subtle hues for HBF — and she's still decorating houses and apartments for private clients from coast to coast. ⚲ With such a lively career, it's little wonder that Barry prizes comfort, ease, and luxury at home. And in her bedroom, she has created a sense of real tranquility, an air of luxurious simplicity. Monochromatic and serene, it's a room that immediately calms the mind. ⚲ "I have the most beautiful cotton sheets and pure down pillows on my bed because I believe in everyday luxury," said Barry. Luxury is not something to be saved only for special occasions, she insists. Using a silver tray for morning coffee in bed — and by all means bringing out the linen napkins, the best china, a favorite book, and a lovely flower — will enhance the beauty of the moment.

Barry, who has a particular fondness for such thirties French designers as Jean-Michel Frank and Jacques-Emile Ruhlmann, has furnished the bedroom with chairs, an armoire, and bedside tables all with the chic lines of a Paris salon. Upholstery in monochromatic wools, linens, and cottons is her favored direction — along with pale sage walls. Color is elusive and held back, the light diffused. ⚲ Patterned sheets are not in the natural Barry vocabulary. Instead, she selects Peter Reed pure-finish hemstitched Egyptian cotton in pristine white.

Pillows are plumped with Polish down for the most lightness and loft. The upholstered headboard is simple and unobtrusive. Barry's approach to room design is to formulate a somewhat unadorned, structured background — and to add texture and "pattern" with chairs, lampshades, and accessories.

OPPOSITE & ABOVE Pure perfection: Afternoon light spills into Barbara Barry's bedroom through wooden shutters and falls on a Giacometti-inspired plaster lamp by Sirmos. Barry appreciates simple, practical bedside tables with room for books and a generous surface. Objects come and go, but the eye- and skin-pleasing cotton sheets are constant.

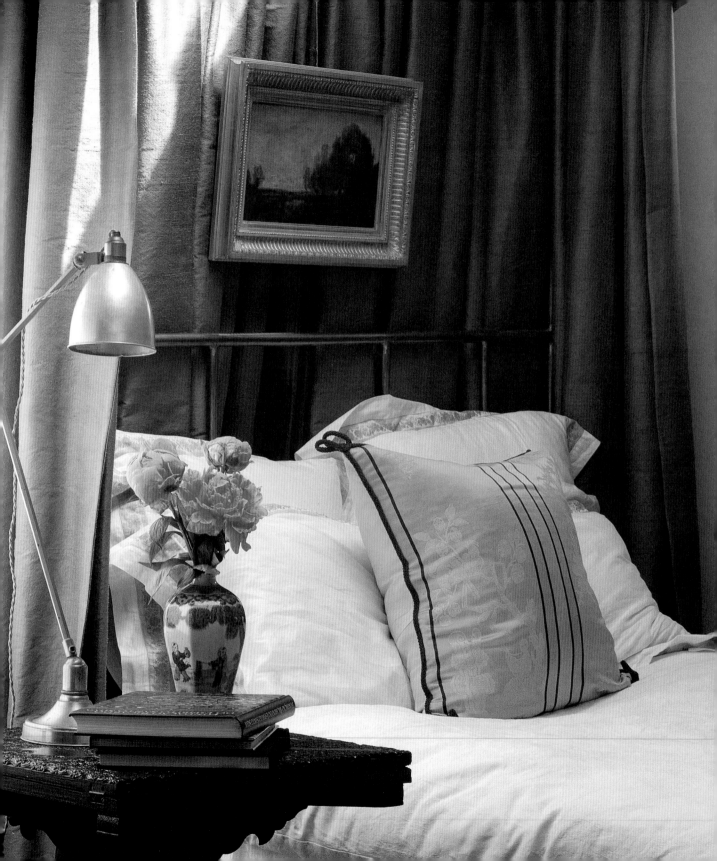

Interior designer Michael Smith, who lives in Santa Monica, believes that creating truly personal rooms takes a great deal of trial and error. And it should not be rushed. He will take months or years to find an exceptional chair with a precisely curved back, a headboard with an interesting provenance, a pillow made of antique textiles, or a plein-air painting of a particularly beautiful California scene. ⚷ "Taking your time, looking for just the right things, and buying antiques of whatever style or period you favor gives an opportunity to experiment and perhaps rethink a plan," said Smith, who antique-shops at top-notch galleries in Paris and London. ⚷ "Custom-made furniture is wonderful, but vintage furniture and antiques have the advantage of offering no surprises," Smith said. "You can buy an antique lamp or bed or table, bring it home and live with it and get to know it. New furniture has its place, but antiques and one-of-a-kind treasures are the pieces you keep." ⚷ Smith insists that the days of buying a pretentious or prepackaged look are truly over. "Your house and bedrooms must be relevant to the reality of your day-to-day life and where you live," said the designer. Bedrooms should not be theatrical or showy, unless that's what you truly are, he said. ⚷ "I recommend classic, simple rooms, with some quirkiness and eccentricity," said Smith. "Formal English baronial-style or French chateau look-alike rooms are probably inappropriate and possibly laughable." ⚷ Smith is in favor of eclecticism. Most people don't realize that traditional bedrooms cry out for the contrast of a smoothly reductive twentieth-century piece or two to give them an edge, he said. Equally, contemporary rooms demand the patina, richness, craftsmanship, odd coloration, heft, and surprise of well-crafted antiques, simple painted woods, paintings in gilded frames, textured vintage fabrics. ⚷ "It's a mistake to think that decorating means following certain dictates," Smith noted. Bedrooms should be personal, comfortable, and above all individual, he said. ⚷ Smith's flexibility and graciousness with his clients is legendary. The accoutrements of children, dogs, sports, work, and day-to-day activities may not always be perfectly aesthetic. But good design accommodates real life. Antiques are essential. He enriches each room with chairs and armoires, desks, old fabrics, paintings, and other feasts for the eye and soul. Carefully chosen, quality furniture and antiques will reward you, give pleasure, and become part of your life.

OPPOSITE White nights: Interior designer Michael Smith's bedroom is lit by both a skylight and a small west-facing window. The steel bed is draped in luscious gray Thai silk. Function and comfort are important to Smith. "A room should be beautiful, but it has to work, too," he said.

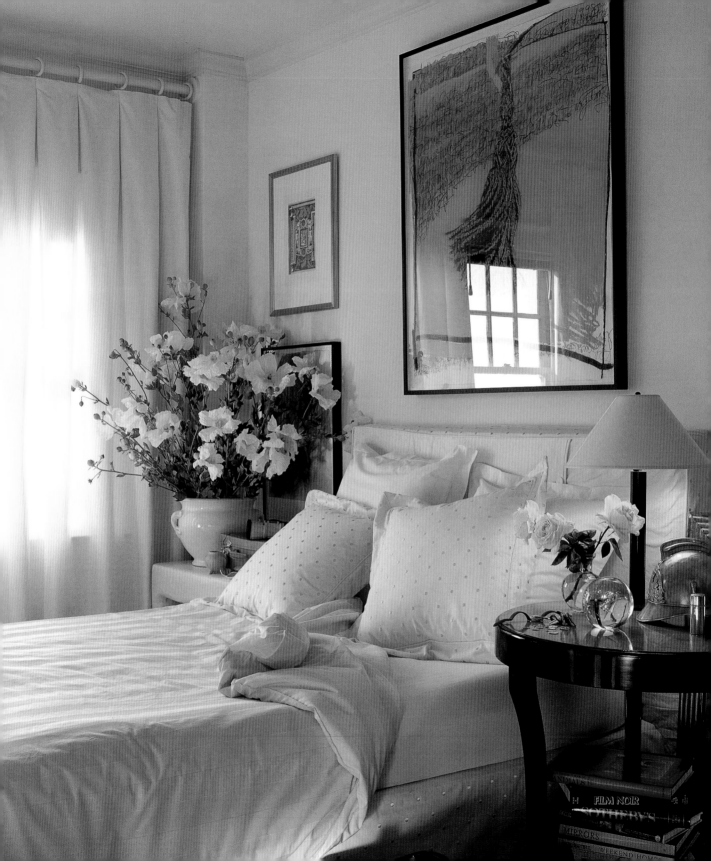

It always feels like splendid summer in interior designer Stephen Shubel's Berkeley flat. The designer's sunny scheme for his own west-facing bedroom includes Tuscan gold walls, framed pastel drawings by painter Woody Biggs, and a comfort-cued chair slip-covered in piped white sailcloth. ⚲ Beside Shubel's bed stands a big white porcelain bowl of California native matilija poppies, their round golden centers mimicked by the golden dots embroidered on his white pillows. It's an inviting scene — cool even in the late afternoon sun. ⚲ Summer is Sacramento-born Shubel's favorite season, and it gave him the perfect excuse to experiment with color and create his rooms anew. He painted his bedroom rich Tuscan-afternoon cream outlined with white molding, bared the bleached hardwood floors, and opened up windows with simple washed denim draperies for daylong light. A second bedroom for Woody Biggs was painted mint green, with white-washed denim draperies. ⚲ "You don't want your bedroom to look too formal in summer," said Shubel, admired for his relaxed approach to chic decor. "Remove some of the clutter, take up the carpets, open the windows, turn on the music, let the rooms breathe."

Decorating does not have to be so serious, insists Shubel. ⚲ The designer had purchased his flat in a venerable 1919 Berkeley building 13 years ago and up to that time the rooms had been more formal. Now his cosmopolitan collection includes a marble-topped neoclassical French table, Italian architectural fragments, a simple Italian desk, a Marché aux Puces chipped-gold mirror, and stacks of design books as tall as his Donghia coffee table. ⚲ Shubel has always been a practical, nondictatorial decorator, who will reassure his clients that their likes and dislikes do not have to be trampled in the cause of "good taste" and "correct decorating." In his own bedroom, he follows his heart. ⚲ Shubel, restless creator and endless experimenter, insists that his rooms can switch as easily as night and day. Naturally, he does not believe in rigid, overdone rooms that will resist minor or major alterations. ⚲ To make decor changes with little worry, the designer recommends starting with white or neutral-colored walls. Give the bed a plain headboard. ⚲ "It's easier to make quick transitions when the walls and floor are not elaborately patterned or in a strong color," said Shubel. "White, cream, gold, or taupe walls and a plain floor give a blank canvas."

OPPOSITE Tailored: A button-down oxford-cloth headboard slipcover and bed skirt come off at the end of summer, to be replaced with the bed's winter "clothes" in warm wool flannel. Crisp white refreshes this small bedroom in Shubel's flat. The designer's credo: Loosen up! Play with design and have fun with color and decor.

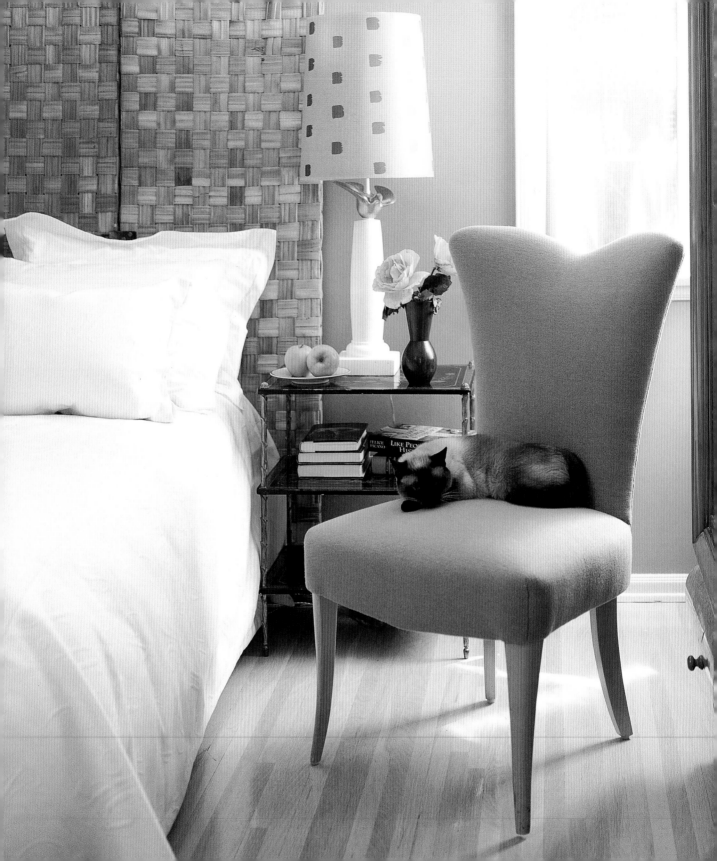

In one of Los Angeles' ubiquitous thirties bungalows, interior designer Michael Berman has fashioned a serene green-walled sanctuary, a bedroom where he reads, watches television, draws, and plays with his beloved 18-year-old Seal Point Siamese cat, Kato. ⚥ "I wanted a peaceful, eclectic room," said Berman, who shares his house with clinical psychologist Lee Weinstein. "We're both busy all day with our work, so it's important to turn off the noise and pressure at the end of the day." ⚥ Afternoon sun streams into the 16-foot by 16-foot room through steel-framed windows. The house, in the Streamline Moderne mode, was built in 1937. ⚥ Walls are painted Berman's favorite green, a delicious concoction of celery and chartreuse. "Green and white is the scheme here. It's crisp and refreshing and ideal for Sunday paper reading," he said. ⚥ This is essentially a neutral, though far from bland, color scheme. Seasoned interior designers like Berman know that tones such as sage green, chartreuse, celery, Tuscan gold, even Pompeiian red, can be perfect choices for "background" colors. They make white linens look their best and seldom look mundane or flat. ⚥ On one side of the bed is a chinoiserie night table with an Alberto Giacometti "Paloma" lamp. Its parchment shade has brushstrokes of gold. On the other side of the bed is a T. Robsjohn-Gibbings modernist nightstand in mahogany. The bed is covered with a Pierre Frey "Monogram" *matelasse* blanket cover. Palais Royale sheets are white-on-white damask. ⚥ Along one wall, Berman has placed a Biedermeier-style satinwood bibliotheque, on which he displays white art pottery, books, and vintage prints. He puts clothing and linens in wardrobes and separate closets to keep everything out of sight and orderly. ⚥ "We love relaxing, reading, and watching television and so we probably spend more time in the bedroom than elsewhere in the house," said Berman. "I am obviously not a believer in banishing the television from the bedroom. Ours is set in an armoire with doors, so it doesn't take over the room. Television is a fact of daily life. I don't think it's wise to turn your bedroom into a cineplex, but you don't have to go to great lengths to hide the television." ⚥ In Los Angeles' cool evenings, Weinstein and Berman throw open the tall windows. Outside, palm trees rustle in a light breeze. Kato dreams cat dreams. It is indeed a peaceful scene.

OPPOSITE Everyday comfort: Michael Berman's cat, Kato, snoozes on his "Horst" chair. The bed's headboard was improvised from a fifties screen of woven palm leaves. Draperies and palm trees in the garden mute the sun that brightens the room – and the cat sleeps on.

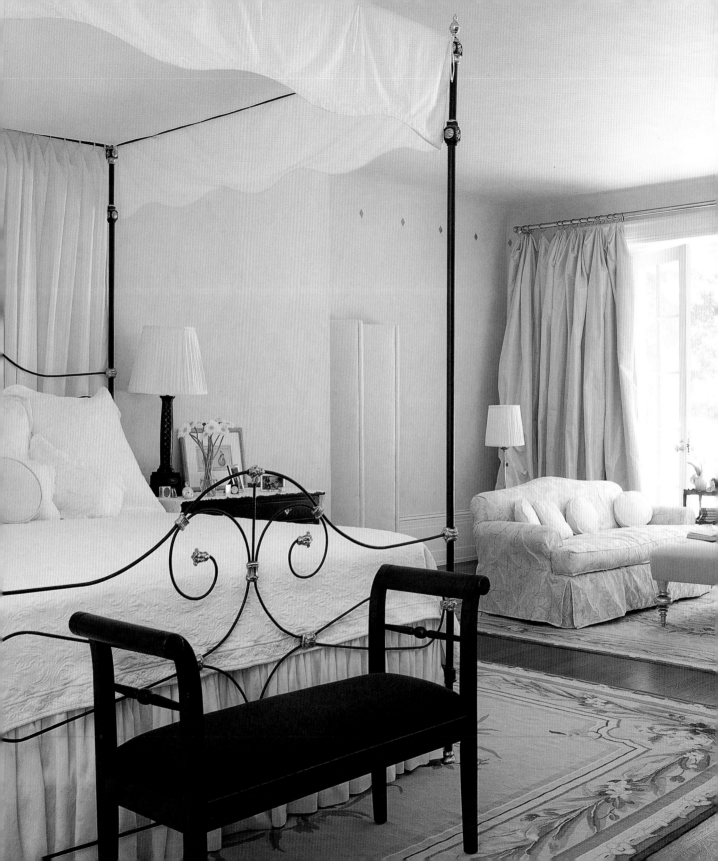

Los Angeles interior designer Kerry Joyce has much to teach the world about subtlety in design. He prefers simple, clean-lined, and unfussy rooms — but believes that understated rooms can still be very romantic. For one of his favorite clients, actress Jamie Gertz, Joyce designed a dreamy bedroom using only white, ivory, cream, and muted sienna — that still manages to look rich and luxurious. ☿ "I think of this bedroom as 'Victorian Shaker' because it has very strict lines in the architecture, but it has intricate and refined detailing and a curlicue or two for contrast," said Joyce. The 400-square-foot, L-shaped bedroom has panelled doors, and walls glazed with pale layers of cream and a touch of sepia. Extra-tall 16-inch baseboards give a feeling of substance. Joyce emphasized the graceful height of the room by designing a coved ceiling. ☿ The antique iron bed, like most old beds, was a double, so Joyce had it expanded to queen-size. New iron work was in keeping with the spirit and integrity of the original. Joyce likes tailored bed linens, and selected a *matelasse* coverlet, antique *matelasse* pillow covers, and a ball gown-ish Egyptian cotton bed skirt, all in white.

☿ The sitting area, which overlooks the garden, has two sofas upholstered in cream Scalamandre damask. Pale colors, Joyce believes, are always a way to get the background of a room right. Brighter colors or patterns can be introduced later. ☿ Joyce always adds a grace note to a renovated room — one odd, unexpected detail that takes the room out of the mundane. In Gertz's room, it's a small bow-topped window high above one side of the bed. Gertz and her husband can glimpse tall trees that surround their house. ☿ "I think of this window as a 'character' window," Joyce noted. "It has prominent molding and although it's new, it looks as if it was handcrafted and is original to the house. Sometimes it only takes one inexpensive detail like this to make all the difference." ☿ The draperies of silk taffeta are backed with lightweight blackout fabric to keep out light. ☿ Joyce admires generous fabric. These draperies bursting forth from a simple curtain rod are typical of his combination of subtlety and hidden luxury. Drawn in the evening, they enfold the room in quietness and repose. Pulled back, they reveal French doors and a green and white garden. Luxury does not have to shout.

OPPOSITE Dreamy colors: Los Angeles interior designer
Kerry Joyce covered Jamie Gertz's hardwood floor with an Aubusson-
style rug in faded tones of taupe, moss, cream, and chestnut. The antique bed
was redecorated with 23-karat-gold water gilding.

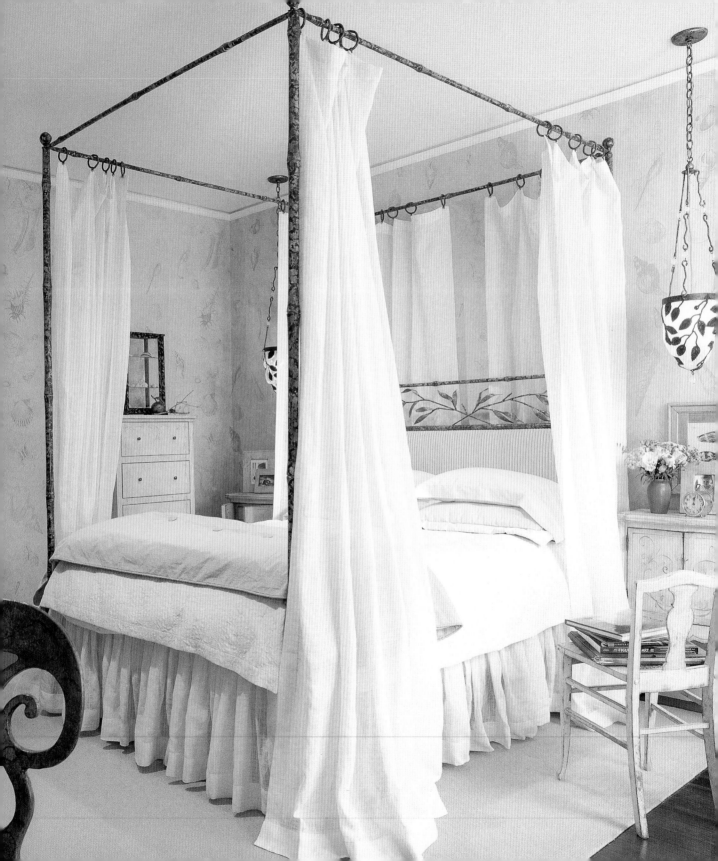

Iron is the chosen medium of San Francisco designers Kate McIntyre and Brad Huntzinger. Ironies — their Oakland-based, nationally admired company — manufactures iron, stone, and wood beds, tables, lamps, chairs, and accessories. They have recently branched out into blown glass and iron lamps, and are now presenting a line of hand-colored wallpapers. Art of the Muse, their painted-finish company, specializes in subtle, evocative designs. ⚲ "Because metal can look very cold and rigid, we always try to bring an ethereal quality to our bedrooms," said McIntyre. "The iron four-poster offers form, structure, and 'architecture' to the room, but if it isn't softened with fabrics and antiques it can look somewhat unfriendly." ⚲ The room itself, measuring 14 feet by 12 feet with a 10-foot ceiling, was not lacking in good proportions. One large window overlooking a Spanish-style courtyard faced east, so morning light, the classic alarm clock, was plentiful. ⚲ McIntyre and Huntzinger, concerned about form, also brought in substantial furniture. An antique walnut armoire stands like a sentinel facing the bed and gives the room a sense of solidity and stability. (This is, after all, earthquake country.) ⚲ "The bed, with pure linen draperies, is now almost like a room within a room," said McIntyre. "Gauze and silk are often considered feminine, but men like this kind of room, too. I like the feeling of enclosure it offers — the feeling of leaving work behind." ⚲ McIntyre accompanied the bed with a pale blue-green hand-painted dresser and bedside tables by Patina. On the

walls are Ironies' new handprinted and color-washed wallpapers, Shell Study, based on old shell prints. The sheer fabrics and tissue silk — and colors ranging from pale sea green to celadon, ivory, and pale sienna — add an elusive, translucent quality of light to the room. ⚲ "Brad and I are both obsessive about the subtlety of walls," she said. "We want them to look interesting but not demand attention." They achieve that balance by designing papers that duplicate the look of their own stenciled and hand-painted wall finishes. ⚲ "Mottled and antiqued colors on a wall add to the richness without looking over-patterned," said Huntzinger.

OPPOSITE & ABOVE Sleepytime: At a recent San Francisco Decorator Showcase, designers Kate McIntyre and Brad Huntzinger posed an Ironies "bamboo" bed crafted of wrought iron in the center of this bedroom. It is draped with Roger Arlington sheer linen and dressed with Paper White linens. A Bergamo *matelasse* blanket and Nobilis duvet cover with a sienna welt complete the ensemble. The headboard is in striped Nobilis velvet. The floor is covered with a plain, flat sisal-weave wool carpet.

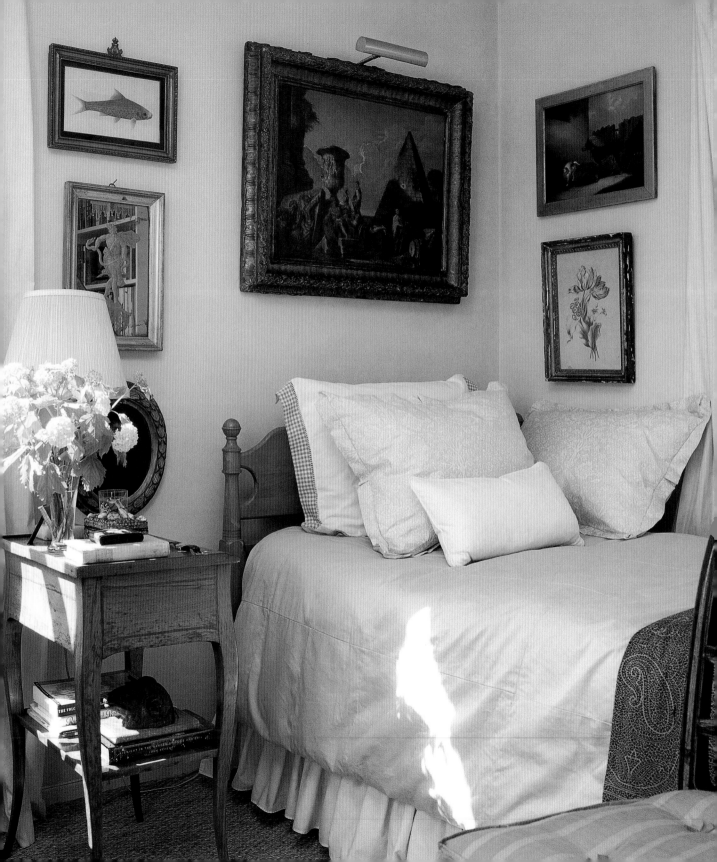

The tiny bedroom of Los Angeles interior designer Andrew Virtue is proof that even a small room can be interesting, fresh, and bursting with ideas. Virtue's bedroom measures just 10 feet by 10 feet, but he has made it into a comfortable, witty, welcoming retreat. The former maid's quarters of a grand Long Beach estate, his rooms are one block from the beach and benefit from a large terrace with grand views toward Catalina Island. "I think of this bedroom as a collector's cabinet," said Virtue, whose antiques store, Virtue, is a bright spark in the Southern California design world. "Since the place is so tiny, I decided to fill it up with a lifetime's collection of objects, fine antiques, paintings, and flea-market treasures." Virtue's contrarian tack goes against design lore, which suggests that the best way to deal with small rooms is to decorate them sparsely with large furniture. His approach challenges old rules and gives the room its upbeat individuality. Positioning overscale furniture in a small room, say designers, gives the room a sense of importance and drama. But extra-large pieces can run the risk of looking like elephants in a dollhouse, and (also like pachyderms) can be very difficult to move around.

"I'm stubborn, and I decided to ignore the fact that this is really minuscule," Virtue noted. His groundwork, however, was sound. "I've got every shade of neutral, from cream to white, and from black to tan and sepia," he said. Virtue painted the walls Navaho white, covered the floor with seagrass matting, and dressed the windows in bleached white muslin ("the cheapest fabric going"). Virtue embraces a range of styles of furniture and combines them confidently. His daybed, whose ball finials and pale color suggest a French Provincial version of a Directoire piece, was actually put together from his father's and uncle's childhood headboards. The bed has a quilted cotton duvet cover, Fortuny shams, hem-stitched linen pillowcases. A nineteenth-century Scottish paisley shawl adds a dash of blue and cream. Above the bed hangs a gilt-framed oil-on-canvas, circa 1740, depicting Grand Tour Roman antiquities. Other pieces include an eighteenth-century night table, a French alabaster lamp, and an Italian walnut card table used as a writing desk. "A small room should still be full of things — and it's important that they're terrific because everything is right in your face," advised Virtue.

OPPOSITE Small wonder: Leaving beachside cliches at the door, interior designer Andrew Virtue decorated his petite apartment with Italian paintings, twenties lamps, time-machine collections, and an air of insouciance.

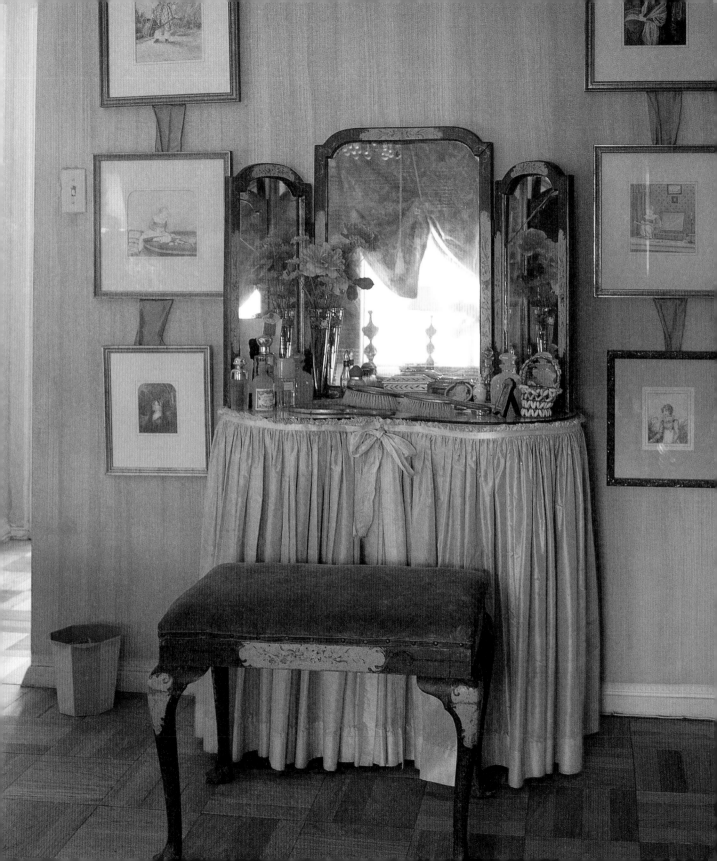

Interior designer Kate Stamps, who is a partner with her husband, architect Odom Stamps, has fervent opinions about bedroom design. She prefers a room that perfectly fits the dreams and personal comforts of the people who will use it. ☿ "If you've always wanted an eighteenth-century French bedroom or an evocation of a Moroccan tent, then this is where to make it a reality," she said. "A bedroom is one place where we don't have to consider the needs and wishes of the entire family, visitors, or friends. We can make it all-white, keep it spare and very Shaker, or whomp it up into a lavish and lovely boudoir." ☿ While some designers like a severely edited, understated look, Stamps believes that bedrooms benefit from a more recherché but pleasing collection of furniture. ☿ "Very few bedrooms should have matching 'sets' of furniture," she said. "When everything is the same style, it makes a room look uptight and impersonal, like a hotel." ☿ Instead, Stamps suggests contrasting an old hand-carved four-poster with a Scandinavian painted chair and perhaps a newish Louis XVI-style settee. If the (unmatched) vintage bedside tables have worn spots and chipped paint, so be it. She also likes white cotton Marseillaise bedcovers, intricate old needlepoint rugs, and throws of vintage fabrics. ☿ "A bedroom should be a relaxed place, with beautiful things you love that have gentle wear and patina," Stamps said. "Antique textiles, faded mahogany furniture, old Oriental rugs, and furniture that's been in the family for years will give you a sense of comfort and permanence." ☿ Like

most interior designers, Kate Stamps is always dreaming of her next bedroom. This year (but perhaps not next), her fantasy bedroom is a small, cozy, low-ceilinged room evocative of a six-teenth-century French or English manor house. The walls would be creamy white plaster, not painted, and hung with tapestries and bold oil paintings. ☿ "Perhaps as an antidote to the modern world, all the furniture would be dark, substantial, and old," said Stamps. "Books would be piled all over the tables and floor. The bedside tables would be covered with flowers, family photos, and mementos."

OPPOSITE & ABOVE Bedside manner: In Kate and Odom Stamps'
Los Angeles bedroom, a well-orchestrated collection of paintings and furniture
makes a pleasing composition. The room is not especially large, so chairs,
tables and a bookcase are somewhat small in scale.

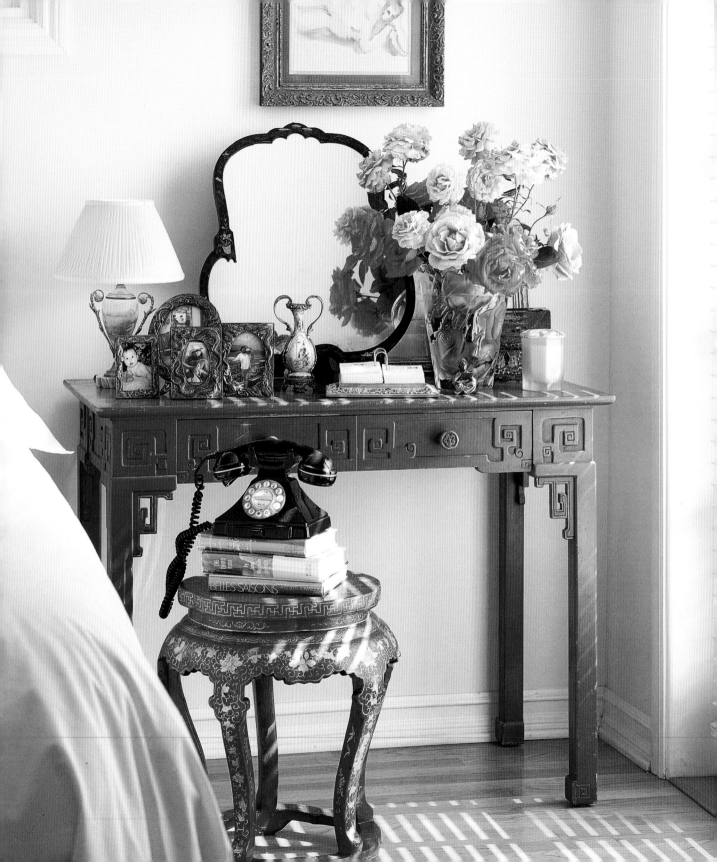

It has the air of perfection and chic that suggests languorous days and nights in mythical, romantic Hollywood. Melissa and Geoffrey Deitz's Spanish-style Hollywood Hills house, built in the twenties, is a haven from fast-paced Los Angeles, but it's far from precious and uptight. ⚲ This is a house that welcomes two large and beloved black Bouviers des Flandres, who loll for hours on the Italian linen sofas, lounge on the white cotton bed sheets, snooze afternoons away in the living room, and snuffle on the carpets. They're part of the family. They also shed. ⚲ "My passion is beautiful white bed linens, which I buy all over the world, but I wouldn't dream of shooing Max and Maud off my bed," said Deitz, who owns W Antiques and Eccentricities in West Hollywood, near the Pacific Design Center. "We love the dogs, and we enthusiastically accommodate them and their likes and dislikes. They prefer sleeping on our bed, so I cover it with white cotton sheets that I can easily wash." ⚲ The bedroom was added to the small house as part of a careful remodel. Deitz painted the walls her signature cream (a gorgeously rich custom-mixed tone that she calls Beverly Hills Bone) outlined with crisp white moldings. The windows are covered with wooden plantation shutters. From her treasure trove of antiques and vintage textiles, she selected a 1920s Chinese desk for a bedside table. On it, she arranged a chinoiserie dressing table mirror, a bronze dore desk calendar, a reproduction vintage telephone, and a Lalique vase filled with roses from her garden. ⚲ A waxed hardwood floor offered up a neutral background for

her punched-up red lacquer two-drawer desk, circa 1925, and a romantic French marble and bronze lamp with a hand-pleated silk shade. The Franco-Chinese story line is iterated with a Parisian vase, a Chinese red lacquered and gilded stool from the turn of the century. On the desk, a collection of Chinese export silver frames, a Franco-Chinese vase with bronze doré decoration and a Chinoiserie document box. Melissa found her treasures on forays in London, Paris, New York, and Los Angeles. (As a special favor to photographer Jeremy Samuelson, Max and Maud gave up their favorite positions on the white Frette sheets for this photo shoot.)

OPPOSITE & ABOVE Hollywood nights: Antiques dealer/interior designer Melissa Deitz and her husband, Geoffrey, added this new bedroom and a bathroom to the Hollywood house they share with their beloved dogs, Max and Maud. Here, pale creamy beige painted walls, white-lacquered woodwork.

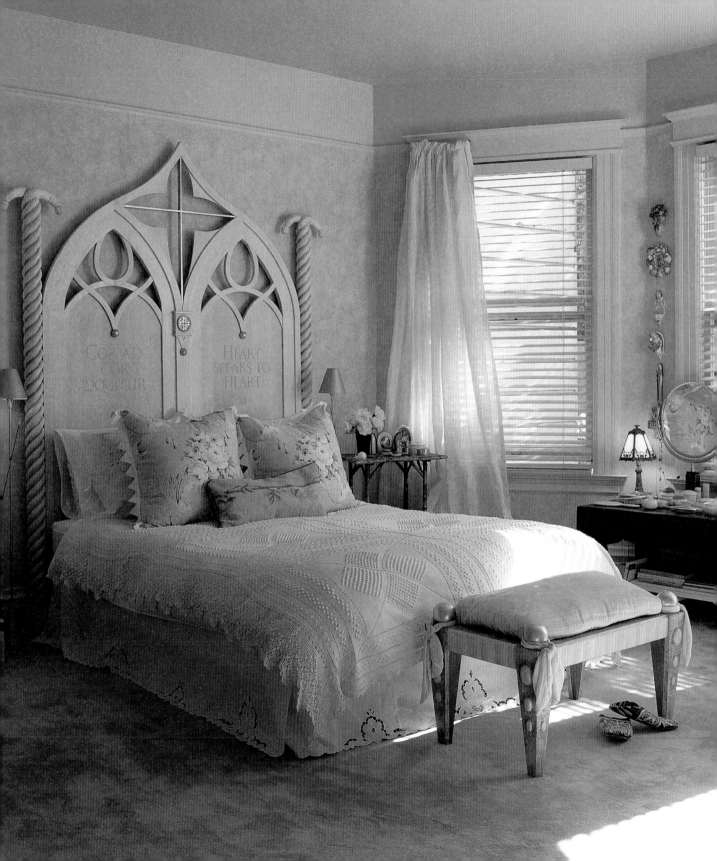

Arnelle Kase's design irreverence turned the tables on her family's handsome Edwardian house on a hillside overlooking San Francisco. The two-story residence near Buena Vista Park had been built in 1906 as a genteel home for two unmarried sisters. It had the solid construction, large rooms, and imposing proportions common to its post-Earthquake era. But this versatile San Francisco designer decided that Edwardian was not her thing. Recreating authentic period style, with all the heavy furniture and dreary colors, was out. She has instead decorated the interiors with a light, refreshing touch. Arnelle and her husband, Roger, a business executive, first rented the house in 1971 when they were "impecunious hippies." Arnelle is now an associate with Barbara Scavullo Design and works in a range of styles for clients. "I found antiques for the bedroom on trips to antique shops, flea markets, and auctions all over California, in Hong Kong, Rome, and Paris," she recalled. She covered the walls with an Osborne & Little wallpaper in the pale celadon tones of Aracauna eggshells. Woodwork is pointed up in satiny shades of white and off-white. The bedroom overlooks a quiet garden with a particularly graceful birch tree. "I didn't follow any set plan for the bedroom — except keeping it uncluttered," Kase noted. "Of course, my Ivorine collection has taken over several surfaces. I love the ivory-like color. Each brush and comb and powder-puff holder has its own history, which makes it so much more evocative than a new piece." But most of all, Kase said, her bedroom is a place where worldly cares must be left at the door. "My rule is: no television," she insisted. "And no down-lights over the bed. They're very unflattering. Instead, I recommend adjustable lamps on a bedside table. Occasionally, we light candles." The handcarved headboard with its Gothic overtones and grand height holds its own against the broad bay windows, which seem to scoop up light for the room. Draperies are simple, graceful, and effective with Venetian shades. Kase's bedroom luxuries are simple ones: fresh flowers, family pictures, ironed sheets, antique linens, plenty of books and magazines — and lovely fresh air.

OPPOSITE Hand carved: The heroic bleached-alder headboard was custom-made. The silver-leafed Latin motto, *Cor ad cor loquitur,* means "Heart speaks to heart." ABOVE Garden roses and evocative objects are inspiration for dreaming. A tip for display: Group favorite objects together rather than dotted about a room. There's strength in numbers.

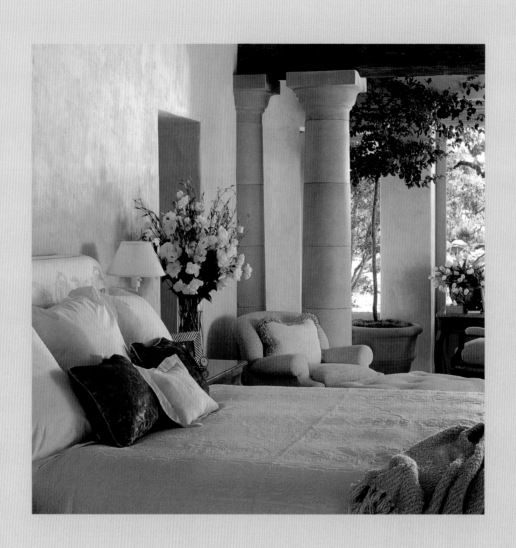

DESIGN WORKBOOK

The finest California architects and designers — who spend their days planning and completing luxurious and highly detailed interiors for their clients — can be surprisingly down-to-earth in matters of renovation, timeless decor, lighting, painting, improvising draperies, even furnishing on a dime. While the pros can effortlessly polish off a bedroom draped with silken taffeta and filled with beautiful antiques, they're magnanimous with their problem-solving tips on making the most of a small room, practical ideas for lighting, and advice for resurrecting thrift-shop furniture. They also set forth suggestions for saving money, and keeping a bedroom simple. Muslin curtains, they say, can be as elegant as silk. Bedrooms don't need to be very elaborate — just comfortable, ingenious, and inspiring. The best plan: always please yourself.

O P P O S I T E O.J. and Gary Shansby's Italianate bedroom in Sonoma County, designed by Tucker & Marks.

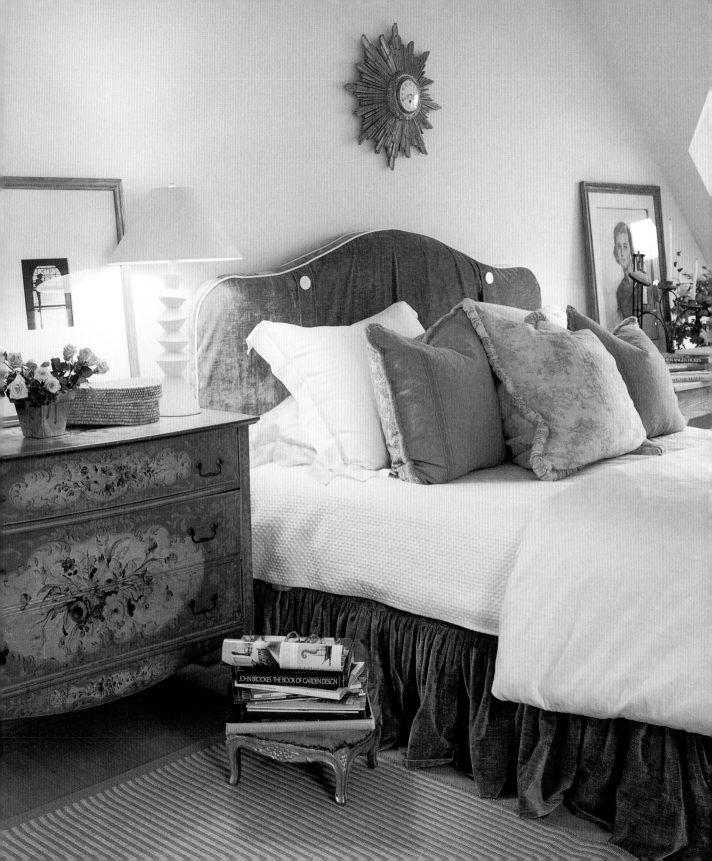

RENOVATING & REMODELING TIPS

Planning a bedroom improvement? First read these mind-expanding ideas from a very experienced architect. Then proceed boldly.

San Francisco architect Dan Phipps offers insight into making bedroom improvements. His favorite tip: fantasize. The best remodels begin with fantasy and dreams. Letting the ideas flow without too much negative, pessimistic, or critical thinking is the best way to begin. Phipps, who works in a range of styles, always encourages his clients to be openminded at the start of the process. The hard decisions — budgets, code restrictions — can come later.

Fireplaces

Many homeowners wish they had a working fireplace in their bedrooms. It's often possible, though costly, to add a fireplace if the bedroom is on the top floor. A masonry firebox will offer more aesthetic control than a free-standing fire, but the floor must be strong enough to support and accommodate the fireplace. A prefab metal firebox is less expensive but you're limited to existing sizes and styles, and the opening will generally be at least four inches above the floor.

Windows

In any remodel of a corner bedroom, try to plan windows on two sides. Redesign windows so that (if appropriate to the style of the house) the reveals (the space between the wall and the window) are at least 12-inches deep. Consider a different style of window — perhaps with an arch, or with smaller panes. Consider a window seat. If it is not possible to enlarge or deepen windows, give new windows substantial trim with interesting detail. This gives the room and the window frame a feeling of style and substance.

Lighting

When bedrooms undergo renovation or redecoration, it's time to plan new lighting. Consult with a lighting designer about the two or three different kinds of lighting a well-lit (and highly functional) bedroom needs. Ambient lighting (overall lighting) should be a combination of lighting such as wall sconces, recessed ceiling lighting, table lamps, and adjustable track lighting. In addition, spot lighting for paintings and task lighting for a desk or reading area are necessary.

Skylights should be avoided unless the room will be too dark without them — or there is an efficient way to block early morning light. They are often hard to keep clean, and some architects are convinced that they eventually leak and that they can cause structural problems.

Ceilings

An experienced and imaginative architect may be able to figure out a way to raise a somewhat low ceiling, or to vault the ceiling. If the ceiling can't be reconstructed, it could be restyled — perhaps to give the appearance of coffers or beams.

Encourage your architect to dream up new ideas. Discuss pros and cons in detail. Don't initially veto ideas for fear that they'll be too costly. Perhaps a money-saving solution can be worked out.

OPPOSITE Versatile and cozy: This bedroom, designed by Stephen Shubel, was created in the former attic of a tiny Victorian house. The window at right fills the room with all-day light. The headboard is slipcovered with moss velvet.

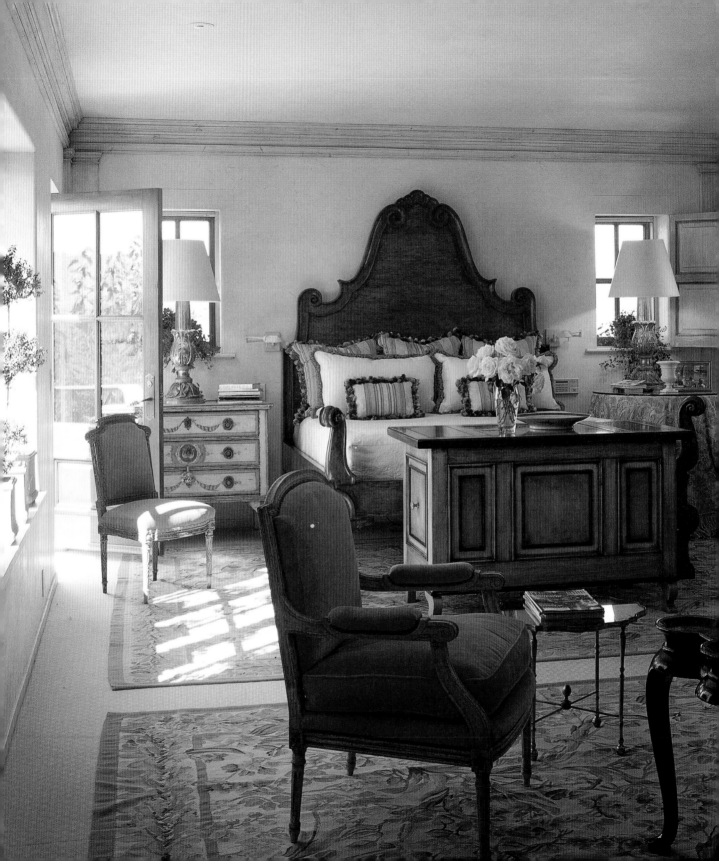

TIMELESS DESIGN

Good designers know how to shape bedrooms that please from one decade to the next. Their advice: Avoid trends.

The bedroom looked lovely when it was decorated six years ago. Time flies. Now the room looks dated. A guest bedroom used to look fresh and wide-awake. Now it just looks tired. How do decorators create rooms that look better over the years? What gives rooms staying power?

Top interior designers say that it is important to avoid today's trendy colors and furniture, to forgo fads. Choosing simple, classic fabrics, white sheets, non-fashion patterns and hues, and well-made furniture with good proportions will prevent buyer's remorse. Today's whims are often tomorrow's embarrassment, as the great New York designer John Saladino observed.

Design choices should never be dictated by the latest fashions in home decorating presented in catalogues. Staying away from one-dimensional "theme" looks (such as cliche Santa Fe and trite French Country) and taking a daring, more eclectic approach is wise, say the designers. Selecting vintage and new furniture, finding antiques at auction, and juxtaposing simple pieces with more elaborate elements will guarantee longevity.

Mixing rather than merely matching offers more flexibility, said San Francisco interior designer Gary Hutton. (Matching everything — or "coordinating" — is the mark of an amateur.)

Rearranging furniture from time to time means rooms don't become too predictable and boring, suggested Hutton. Fresh upholstery, swapping a patterned rug for a simple sisal or rush matting gives rooms a lift.

To keep bedrooms current and inviting, say the pros, they should be revived every year or so. Professionals see the advantage of changing accessories, rehanging paintings, bringing in flea-market finds or family antiques, and displaying new collections. Finally, rearranging books, dressing the bed in new finery, and sending draperies out for a thorough cleaning lift the mood. After all, it's a retreat, a haven, not a museum.

"Everyone thinks that once a good room is completed, it will remain static, but that's a fundamental misunderstanding of design," said San Francisco interior designer Michael Tedrick, who always likes to combine antiques and classic draperies. "The best design is an evolutionary process. Needs and tastes change in a subtle way, so bedrooms must also adapt. With the major features of the scheme right, antiques can come and go, paintings may be switched, furniture placement might be reconsidered or improved."

San Jose designer Linda Floyd also believes in starting out with a suitable, simple background of

ABOVE Only the lamp with its tall shade suggests that this bedroom is of the modern world.

OPPOSITE Italian romance: A sunny bedroom in the Napa Valley, designed by Thomas Bartlett. The bed is by Michael Taylor Designs.

classic paint colors or neutral wallpaper and well-proportioned moldings. "The interior architecture and 'bones' of a room should be right, then it can be refreshed and refined without fuss," Floyd said. White wall paint won't date. Nor will rich cream paint, black-and-white-striped wallpaper, petite abstract prints, or subtle pastels.

Floyd contends that buying the best quality furnishings — and insisting on meticulous craftsmanship — will always assure the longevity of furniture, draperies, and decor. "It's better to have fewer things that are the very best you can afford than a lot of mediocre furniture cluttering a bedroom," said Floyd. "Beautifully made chairs covered in inexpensive cotton muslin, a lovely hand-painted Italian dresser, or a well-proportioned headboard upholstered with inexpensive natural linen will always give you pleasure, no matter how many times you move."

San Francisco interior designer Ann Jones, who recently purchased and renovated a 1920s barn in Sonoma, said that keeping decor straightforward means that it can be maintained easily — and rescued from deep dullness every couple of years. "Simplicity doesn't have to mean predictable or boring," said Jones. "With good, plain fabrics, look for interesting textures. Then add low-key details like piping, welting, plain gimp, or a narrow fringe for subtle interest and to give a custom-made look to practical textiles."

OPPOSITE Minimal: Tom and Linda Scheibal's airy Napa Valley bedroom. In the summer, cotton sheets are cool comfort.

BELOW Antiques: A fireplace adds character to a small California bedroom. The bed takes pride of place. Pleasing contrasts: the curvy chair, simple cabinetry.

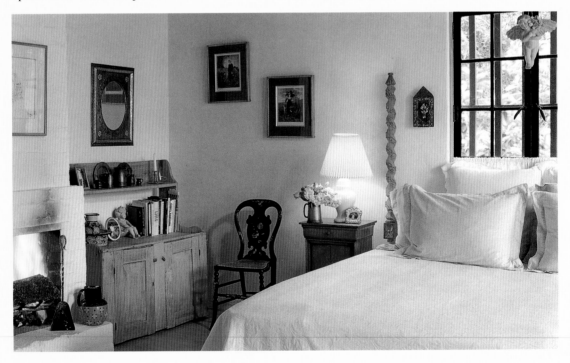

LASTING STYLE: FIVE PHILOSOPHIES, ONE GOAL

1. BANK ON ANTIQUES

- Antiques don't have to be "precious."
- Mix textures like rush matting, leather, woven silk, velvet.
- Mix periods of antiques – it's home, not a museum.
- Buy the best antiques you can afford.
- Choose vintage pieces over shiny new reproductions.

2. TAKE AN ECLECTIC APPROACH

- Eclectic style can evolve.
- Contrast curvy and straight silhouettes, elaborate and simple.
- Don't be tied to out-moded "rules."
- A simple painted back-ground lets you experi-ment.
- Mix simple and rare furni-ture, fine and flea market.
- Don't clutter. Give art room to breathe.

3. COUNTRY SIMPLICITY

- Keep country bedrooms simple and easy to dust.
- Handwoven fabrics and textured walls add interest.
- Where pets sleep, always choose washable fabrics.
- A bold fireplace gives a bedroom instant "architecture."
- Be inventive – old luggage or a Vuitton trunk can be a bedside table.

4. CHIC MINIMALISM

- Start pristine to make enriching the bedroom simple.
- Dress a classic white bed with textured pillows.
- Plain fabrics (white or ecru linens) showcase antiques, objects.
- Move favorite things around. Don't let a room snooze.
- Black with taupe gives a minimalist beige or white room punch without truly adding color.

5. INSIST ON QUALITY

- Buy linens with high thread counts. They're softer, smoother, and will put any thought of polyester blends out of mind.
- Plump the bed with down pillows for a luxurious look.
- Buy extra fabric to be sure that ruffles on custom-made shams are self-backed and not skimpily hemmed.
- Select pattern carefully. Strong colors may look too busy, not restful.
- Choose antiques over reproductions.
- Lace can be lovely – especially if it's heirloom-quality. (Find bargains at flea markets, thrift stores, and charity stores.)

In his Mission District loft, San Francisco interior designer Jonathan Straley has a very scholarly mix of paintings, sculpture, and found objects. "The rigid formality of 'only French furniture' or 'only modernist furniture' has been replaced by more eclectic mixes," said Straley. His wide-ranging interests in art, furniture, books and music are reflected in his bedroom.

The patina of antiques has a special allure for Michael Tedrick. "A well-proportioned leather chair, a chest of drawers with lovely carving, or a mirror with a refined neoclassical French frame will always give you a thrill and never look dated," said Tedrick.

"With antiques you resist that 'instant decor' look that all-new furniture tends to bestow," Tedrick

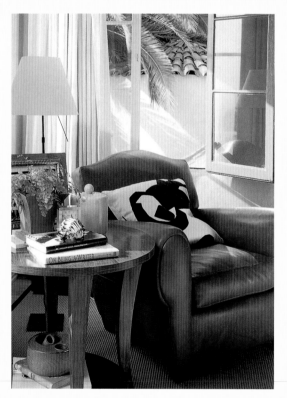

added. When a room looks as if everything arrived brand new on the same truck, it also has the possibility that it will fall out of favor before too long. Flea-market finds, family heirlooms, even garage-sale furniture will rescue a room from that brand-new furniture-showroom look, he said.

Rare craftsmanship, odd proportions, flaking paint, the sheer individuality of antiques will always give pleasure. But expect more from antiques than just beauty, urged the designer.

"I look for versatile antiques that will adapt to many different rooms or locations," said Tedrick. "For example, my three-and-a-half foot by two-foot writing table could be used as a dressing table, a desk, a bedside table. A fine dresser should be able to adapt to a living room, bedroom, hallway, or dining room. Buy only those antiques you love — not the ones you're supposed to like."

Gary Hutton's approach is one that beginners can take. "Chic minimalism can always be added to and warmed up," he said. He recommends starting with simple classic silhouettes — nothing elaborate. Paintings and lamps found at auction can come later. Everything can be upgraded over the years. "Pay attention to the room…don't neglect it," he said. "Then you'll never find it boring."

The other advantage, of course, of having a clear, focused design plan is that you're less likely to be seduced by trendy objects, this-minute colors, or faddish accessories. And perhaps that's the best design secret of all. Creating timeless design saves money — you're buying for a lifetime of pleasure.

LEFT Eclectic: A fat leather chair makes a healthy contrast to the fine-tuned and curvy table and skinny table lamp.

OPPOSITE Contrasts: One-note design has gone the way of the Dodo bird. This bedroom makes its own sweet, serene statement.

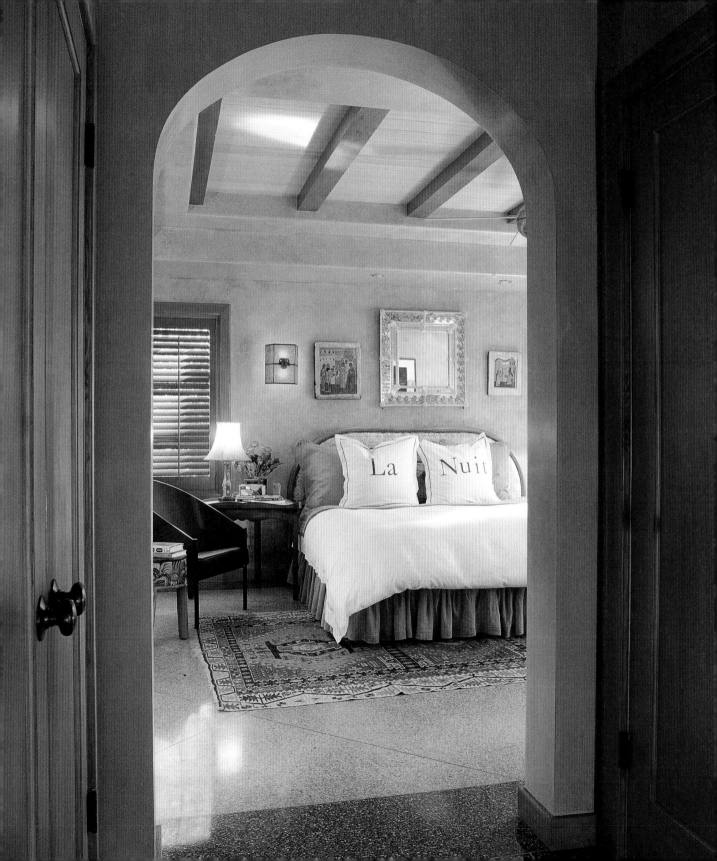

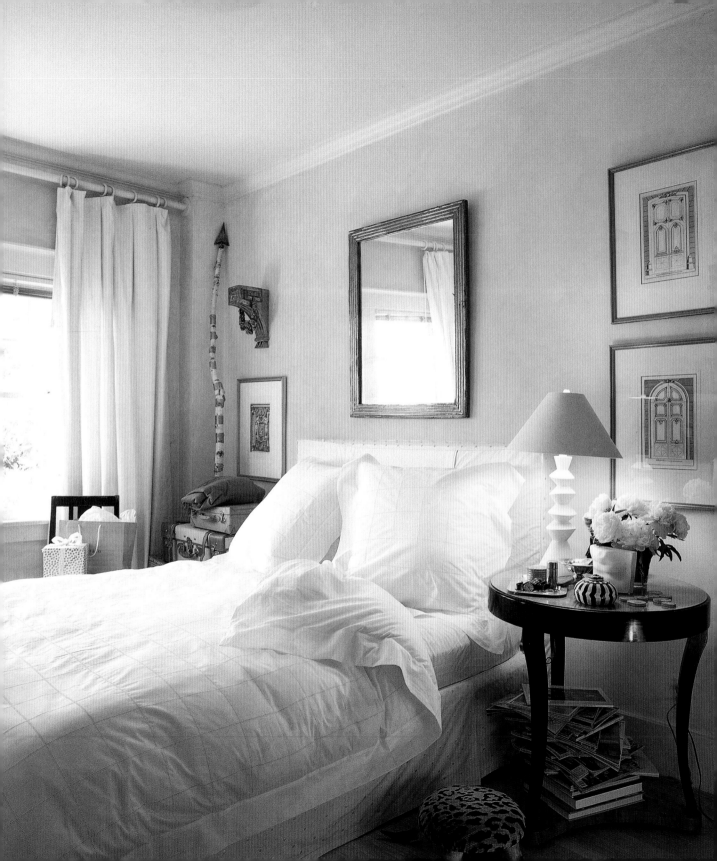

EASY UPDATING

Sometimes, one or two smart moves freshen up a bedroom — without costly renovation.

"The easiest way to change the look of a bedroom is to move paintings and prints and switch around the accessories," said Sausalito interior designer Stephen Shubel. "Put some framed photographs away, and bring out new ones." Experiment with new draperies or a new catalogue-purchased curtain rod. The following are Shubel's time- and money-saving tips.

Dressing

To restyle the bed, dress it with a new slipcover for the headboard and a matching bed skirt. A fitted slipcover can fit over any headboard (including wood) and enliven the room the way a new scarf or a patterned jacket can update a seasonal wardrobe.

Paint

Repainting the walls is often the easiest and cheapest way to restyle a room, so it's tempting to approach it with an experimental frame of mind. It might seem that paint can always be painted over, but it's probably best to do it right the first time. There are some drawbacks to frequent painting: moving furniture, lifting carpets, cleaning the walls, emptying the room, and spending several weekends perched on a ladder. Painting may take longer and become more distracting and complicated if the painting is done by a professional. Labor is expensive.

Neutrals

The word "neutral" has had a bad rap in the design world. It has become synonymous with boring, beige, unimaginative. But there's a good reason to paint (or glaze) walls in colors that bend to many design purposes. "Neutral" can mean different things in a variety of settings. A glossy black floor will be a natural canvas for Oriental carpets or maize matting. Taupe, bone, celery, limestone cream, dove gray, ivory, pale sienna, and honey — as a background color for fabrics or painted furniture and as a semi-gloss or satin-finish paint — will give great flexibility in decor.

Table

Improvise a new side table from a former writing desk, or cover the existing table with an inexpensive cotton dropcloth (they can easily be dyed fresh colors), an old quilt, an old rug, or a tailored tablecloth with a bullion fringe. A reversible cloth becomes a seasonal chameleon.

Windows

Muslin draperies, sheer white lace curtains, or plain white linen Roman shades can be purchased from a drapery shop or home catalogue. They're inexpensive and easy to install. New drapery rods, sculptural finials, and new curtain hooks will give a window a new attitude.

ABOVE A gilded mirror and Biedermeier-style chair add freshness and curves to a small Southern California bedroom.

OPPOSITE Updated: This is the winter version of Stephen Shubel's bedroom shown on page 14. Compare the two styles.

Lighting

Changing bedside lamps — larger, smaller, contemporary, sculptural metal — and putting them on a dimmer will give a completely different mood at night.

Floors

Roll up the carpet and leave the floor bare, with just a small cotton rug beside the bed. Consider painting the floor glossy black or white, and stenciling it with subtle stripes or a checkerboard pattern.

Romance

Improvise a lighthearted canopy with mosquito netting. Hang it from the ceiling and drape it back over the headboard. (It's available through catalogues for less than $80.)

Four-Square

Change the bed to a four-poster. Just be sure that the posts are tall — not squat — and that the ceiling is high enough to accommodate the posts.

Remember that bedside tables don't actually have to be tables. That broad surface you crave can also be a dresser top, a wide desk, a chest, an exotic carved table, or a generous shelf attached to the wall with invisible supports.

OPPOSITE San Francisco designer Orlando Diaz-Azcuy's luxurious bedside table holds irises, books, a quirky lamp.

BELOW Theadora van Runkle's guest room opens to a sunny, private terrace and the verdant canyon hillside. The "bedside table" is improvised from a handsome old dresser painted creamy white.

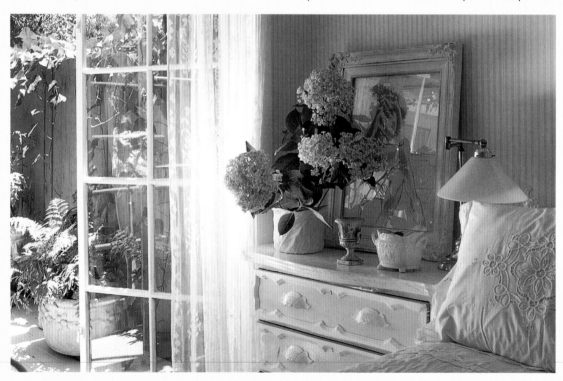

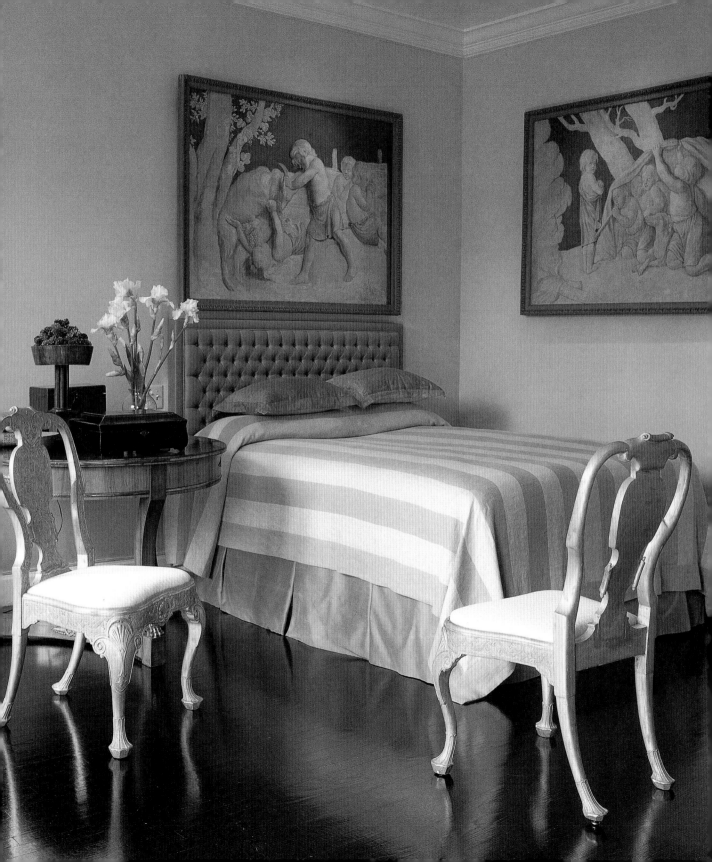

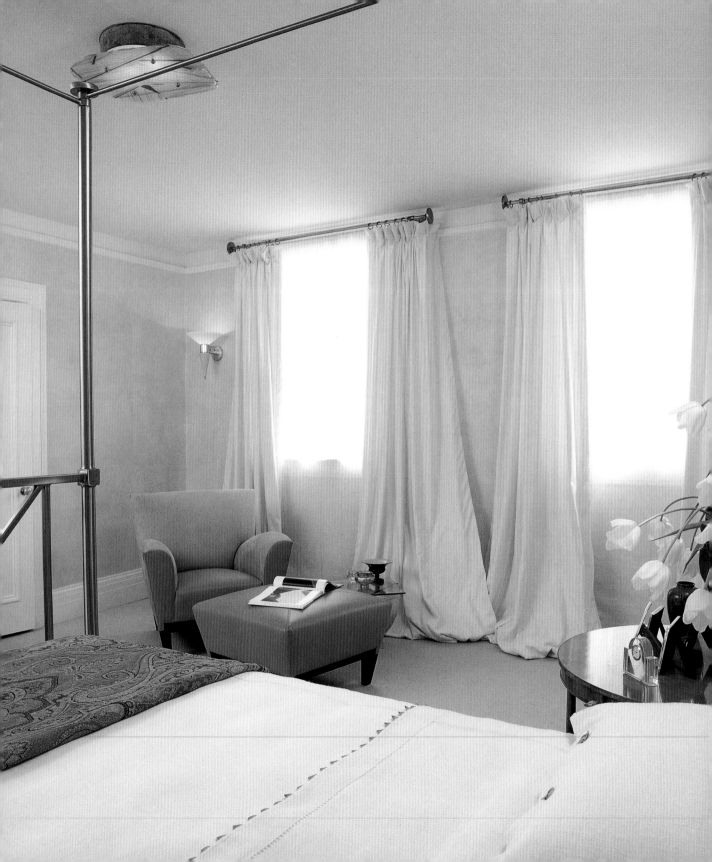

DRAPERIES, STORAGE & FLOORS

Getting the basics right means putting up appropriate curtains, keeping everything in its place, soothing the floor — without costly renovation.

San Francisco interior designer Gary Hutton has more than 18 years of experience designing for a range of appreciative clients. His imaginative but pragmatic approach leads design beginners away from fads and fashions toward a more thoughtful design approach.

Draperies

✦ Light control should be the first consideration of window design. How dark should the room be? Is it completely dark outside at night or do street lights shine brightly? Is sunshine ultra-bright during the day? For efficient light control, select dense fabrics and line them with light flannel interlining to block light completely. Hutton believes that most specialized block-out fabrics are too heavy-duty and make draperies look stiff.

✦ If privacy is the main concern during the day, a sheer lace curtain or a fine linen blind will be effective. For nighttime privacy, it's important to be able to draw opaque draperies, lower Roman blinds, or close metal shades.

✦ Avoid complicated draperies unless the room is very grand and has high ceilings. Simple and uncomplicated is always best.

✦ Matchstick blinds are a perfect low-budget window covering, which can be painted white or cream or left natural. They are usually friendlier, chic-er, and more relaxed-looking than metal shades.

Storage

✦ It may be helpful to have a brief consultation with an interior designer or a closet specialist to maximize storage and use space efficiently. If space is limited and closets must work overtime, special under-bed chests and boxes can be ordered, along with hangers and shelves to use every inch of the closets.

✦ An armoire, a dresser, a bookcase — in addition to giving a room substance, character, and style — will make excellent additional storage. An armoire may be "retrofitted" to make it much more useful.

✦ A trunk or chest at the end of the bed can hold extra pillows, winter blankets, a duvet cover, throws, quilts, or cushions. It also provides extra seating or a place for setting out the day's clothing.

✦ Do-it-yourself wall shelves are ideal for displaying favorite objects, photographs, books, family portraits, make-up brushes.

ABOVE Graphic designer Tom Bonauro's storage is multipurpose. Design: Interim Office of Architecture, San Francisco.

OPPOSITE Swooping silk curtains pool on the floor, giving the bedroom a luxurious feeling. Design: Sutta Dunnaway, Orinda, California.

⇔ The space under the bed should be commandeered for storing boxes of shoes, plastic boxes or trunks of extra linens and sweaters, a fireproof chest of important papers and computer disks, mementos, and sports equipment. The bed skirt will conceal them.

Floors

⇔ If a wall-to-wall carpet is a must (most designers don't love them because they make a room look bland and hotel-like), it's best to select a plain flat-weave wool, a cut-pile wool velvet, a flat-weave carpet, or a sisal-weave wool carpet. All-over pattern is to be avoided — along with elaborate sculpted carpets and lush-pile nylon.

⇔ Sisal — scratchy, prickly, and hairy — is not ideal for bedrooms, where bare feet are guaranteed. Instead, Oriental carpets, worn dhurries, and cotton rugs are softer.

⇔ Hardwood floors are handsome, but there should be at least a small rug on the floor beside the bed to step on.

⇔ Maize squares, which are smoothly crafted, hard-wearing, and cost around $1 a square foot (that means a mere $100 for a 10-foot by 10-foot rug) are an excellent budget choice. The color is usually a pale ivory, the squares provide subtle pattern, and the natural grass is easy to keep tidy and clean.

⇔ Give an inexpensive wool or coir carpet a bit of glamour with a tapestry binding, or a binding of linen tape or leather. (Ask your carpet shop.)

OPPOSITE Smooth styling: Architects Kuth/Ranieri's polished bedroom cabinet has a subtle stain. The floor is cool, easy-clean hardwood.

BELOW Thoughtfully arranged: The comfort of an ottoman; the tidy storage of a simple dresser. Designer: Sudie Woodson.

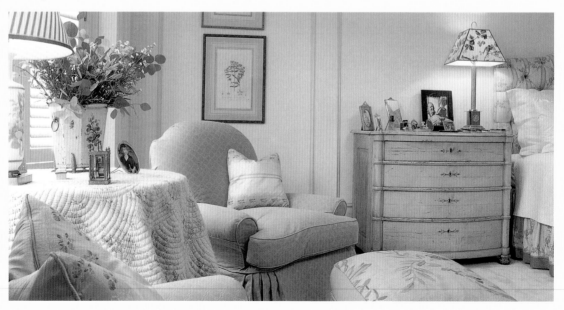

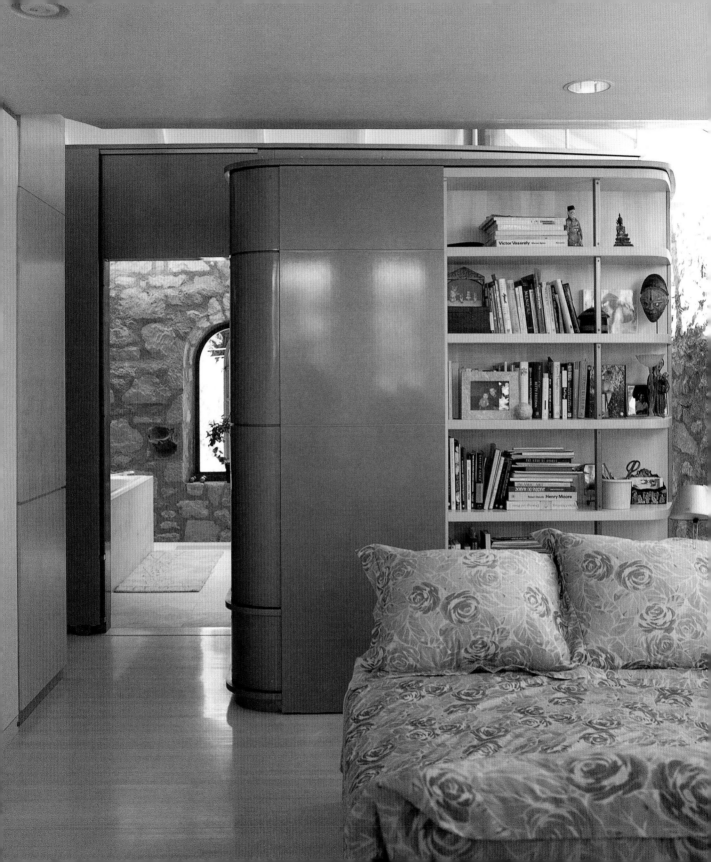

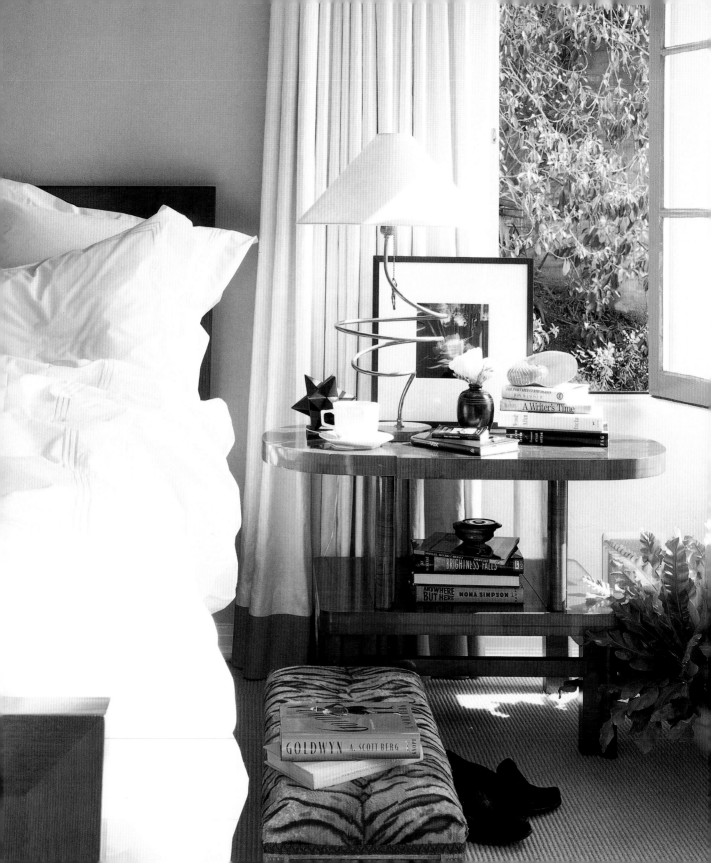

HELP FROM THE PROS

What design professionals know about
bedroom decor.

Space Saver

The best way to get more space on a bedside table — and to arrange better light for reading or sewing — is to mount a classic brass swing-arm lamp on the wall on each side of the headboard. The wiring can be concealed in the wall. An electrician can attach the lamp to the wall with a gem electrical box. Otherwise, install the lamp, run the wire down the wall, and conceal it with a cord cover. Another benefit of these lamps is that they can have three-way bulbs or be on dimmers. With lamps on each side of the bed, one lamp can be on for reading, and the other can be switched off for sleeping. When purchasing the swing-arm lamp, be sure to test its swinging capabilities. Some lamps don't swing smoothly. Airy, sinuous metal lamps, like those shown here, also conserve precious space.

Bedside Tables

Tiny, tippy bedside tables that hold little more than an alarm clock and a watch are to be avoided. Most ideal (if there's space) are somewhat sturdy desks or tables as large as 2-feet deep by 3-feet wide or more. If they have shelves or a drawer, so much the better. A neat, well-edited tablescape of books, photos, a crystal vase of flowers, or an orchid in a terra cotta pot will complete the picture. Perhaps a carafe of water and an antique glass would give pleasure. Pairs of bedside tables don't have to match. In fact, rooms often look more interesting, less expected, when there's a red lacquer desk on one side and an old pine armoire — or their equivalents — accompanying the bed. (They also don't have to match the bed. Bedroom "suites" are

a dated concept dreamed up by furniture manufacturers to sell groups of furniture rather than single pieces. Individually interesting pieces make a room look lived in, and feel like home, not a hotel.)

Floor Coverings

In California and much of the rest of the country, wall-to-wall carpets aren't needed for winter warmth. That's good, because fitted carpets tend to knock the wind out of rooms. Rather than adding luxury, say decorators, carpet covering the entire bedroom floor can make the room roll over and play dead. Soft, flat wool carpet feels friendly underfoot, however, and softens sound. To prevent it from looking like a bland background, leave the perimeter of the hardwood floor exposed. Or if the floor must be covered, design a 6-inch to 12-inch border in a contrasting color, stripes, a Greek key, or a leaf motif.

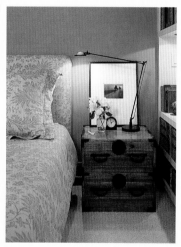

Seagrass, maize, rush, and coir rugs have become popular in the last few years because they offer a simple, unpretentious background — and are quite

ABOVE Antique (or new) Japanese chests make ideal bedside tables or dressers, and assist with precious storage.

OPPOSITE Los Angeles designer Barbara Barry orchestrates a virtuoso display on her table. Note: two tiers of storage.

inexpensive. Many budget-priced rugs are available through catalogues such as Pottery Barn, Crate & Barrel, and Ballard. Those made with linen or cotton twill tape borders look a little more finished.

Home Office

For many people who work at home, full-time or occasionally, the only place to set up is in the bedroom. The trick is to prevent the bedroom from looking like an office. One approach is to convert a closet into the office, complete with doors that close to conceal all the inner workings completely. Hidden inside the closet are a desk with the inevitable computers, telephones, fax, and printer. Broad, sturdy shelves should be fitted across the wall to hold all files, paper, disks, agendas, records. If the computer and other equipment must be in the room, there are several good strategies. One is to set up the desk and file cabinets as far from the bed as possible — perhaps in a corner —

so that it can be concealed behind a fabric screen or a lightweight rattan screen at end of day. All wires should be hidden behind the desk. If the desk will be in plain view — near a window or along the principal wall — neatness and good storage are crucial. Catalogues like Hold Everything (see the California Catalogue at the back of this book) and companies such as Office Depot have extensive offerings of file cabinets, wall shelves, box files, simple wood desks with drawers and shelves, and inexpensive storage units. One way to minimize the office outpost look in the evening is to retire the ergonomic work chair to a hallway and replace it with a decorative painted chair. After looking at the computer screen all day — or pondering files and working the telephone — it is best to

OPPOSITE A practical desk and shelves were artfully fitted into an unused corner. Note the wraparound upper shelves.

BELOW A broad, sturdy table serves as a handsome all-purpose desk. Design: Jonathan Straley and Troy Walker, San Francisco.

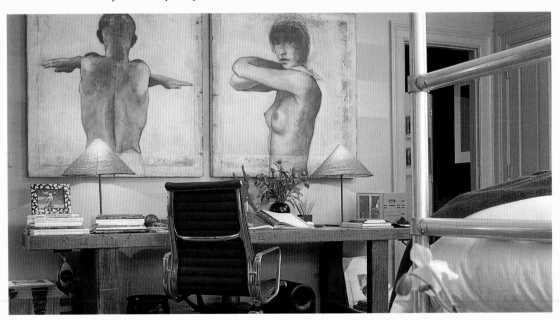

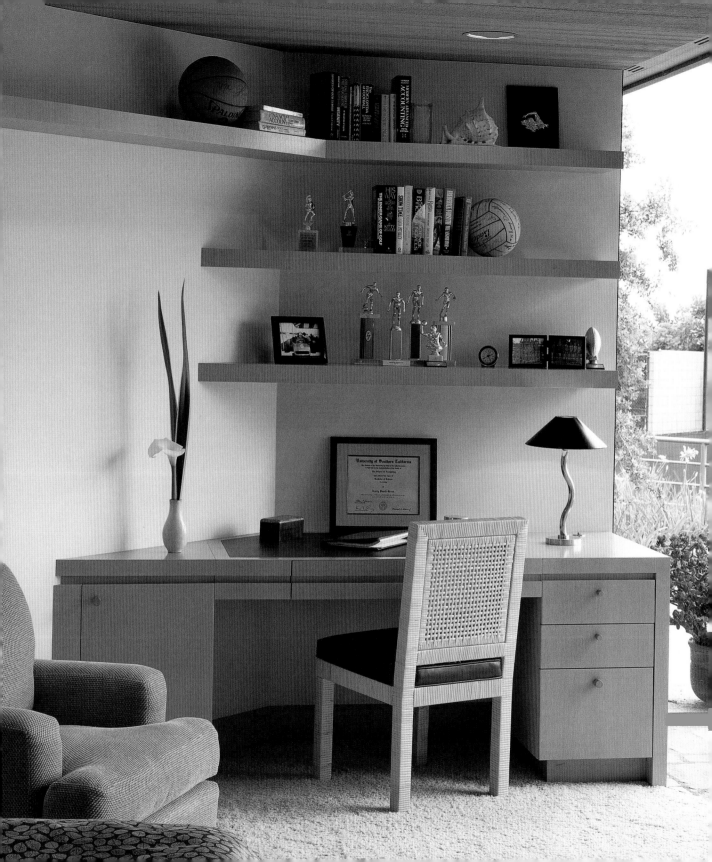

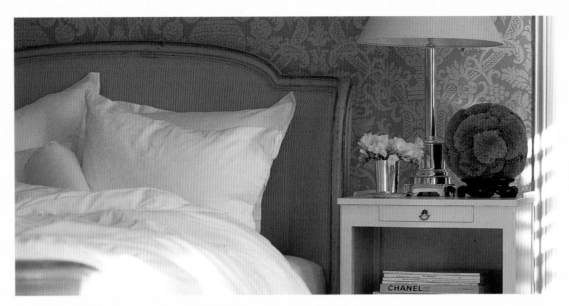

hide the sturm und drang behind a bamboo screen, a sinuous Charles Eames-designed screen, or a lightweight cotton dropcloth. Another tip from designers who work at home: Don't pin pie charts, plans, to-do lists, or clients' phone numbers on the wall where they are visible from bed. It's best to be able to take a thorough break from work at night — and not be tempted to fine-tune the marketing plan.

Television

Many designers are adamantly opposed to televisions in the bedroom. (Others love them.) This should be a place of harmony and reflection — unaffected by the morning news or evening dramas, many insist. But for many people, a favorite form of relaxation is a classic movie or a late show in bed. Armoires and cabinets have been dragged into service as a hiding place for the TV, but that is seldom satisfactory unless they stand on adjustable shelves — or the screen is viewed from an armchair. Designers like the idea of standing the set

securely on a rolling cart so that it can be placed at just the right angle, and rolled away into a closet or behind a screen when it's turned off.

Books

While designers and homeowners debate the wisdom of televisions in the bedroom, books and magazines are on everyone's "must have" list. San Francisco interior designer Michael Tedrick says he prefers the quiet company of books to the noisome intrusion of television. He recommends finding a bedside table with a lower shelf for books. Even better, a bookcase can be custom-made for an unused corner of the bedroom. He also likes books on wall shelves, open shelves above a dresser, the top of a desk, and even on wicker or lacquer trays placed neatly on the floor beside the bed.

ABOVE Controlled pattern: Los Angeles designer Barbara Barry mutes color and pattern. Lamp and table are perfectly balanced.

OPPOSITE Mirrored dreams: San Francisco designer Candra Scott mirrored her closet doors to increase the apparent room size.

Interior designer Kate Stamps, passionate about decor and the inspiring role fine decorating plays in day-to-day life, is also very opinionated about bringing the romance back to bedrooms. Beautiful, full draperies long enough to "pool" on the floor will give a bedroom an air of luxury and visual comfort. Quietness and a sense of privacy are essential.

ROMANCE To be a truly romantic place, a bedroom should have significant personal luxuries. And they don't have to be costly — just special and evocative for the room's inhabitant. All of the senses can be smoothed or stimulated by shiny antique silver vases, favorite biographies, a creamy cashmere throw, a lightweight European down comforter, excellent lighting, a crystal carafe of iced water beside the bed.

COMFORT Plenty of pillows should be at hand to prop up on. At least one should be a somewhat firm 50/50 down/feather blend. A boudoir pillow (sometimes called a baby pillow) can support the neck.

FRESH SHEETS Nothing is more romantic or inviting than freshly laundered (and ironed) white cotton or linen sheets. Embroidery should be simple unless it is the finest quality. The bed doesn't have to be all-white. White sheets can be the background for a paisley blanket, damask shams, a very subtle floral chintz bedcover, perhaps a golden tussah silk bed skirt.

NIGHTCAPS Conceal a coffee or tea maker in a cabinet, armoire, or nearby room for soothing camomile tea or early morning caffeine jolts. If you have room, put a small refrigerator in the closet for cool drinks, ice, or favorite nightcaps. Pretty cups, glasses, a tea tray and napkins can be kept in a drawer to make the occasion special.

BLOOMS In the bedroom, flowers are more necessity than indulgence. Arrange them as if they had just been plucked from the garden. They should be small, loose, and intimate rather than grand and tortured. A small, short-stemmed, and fragrant bunch of pale pink or creamy antique roses mixed with acid green nicotiana, and some striped penstemon "Hidcote Pink" or perhaps pale pink dianthus "Inchmery" will look far lovelier than a dozen florist-style stiff red roses. Those cliche long-stems have no scent and usually die in a rather unattractive and swift manner. Arrange jasmine, pale pink or white peonies, or 'Iceberg' roses in a cut crystal vase or a Worcester sugar bowl that's missing its lid — or in a Regency champagne glass or old silver trophy cup. In the middle of winter, when flowers are less available, burn a subtle candle for fragrance. Naturally scented candles by companies like Diptyque, Agraria, or Guerlain leave a pleasant, clean, lingering scent. Avoid artificial, heavily scented candles.

FLAMES When building a new house or remodeling, be sure to discuss a new fireplace with the architect. Even in warm climates, evenings can be cold. A fire is both romantic and calming.

SOUNDS If possible, have a new sound system installed — or do it yourself with concealed wiring and small speakers. Stock a shelf with favorite CDs. Nothing can create an escapist mood faster than music at the end of a hectic day.

PHONE Some people find a bedside telephone essential — others want to remove themselves from the world. Either use a mobile, or fit the phone with an extra long cord so that it can be moved around the room easily.

CANDLES Aromatherapy candles and scented candles have become popular. Don't forget to use natural beeswax or ivory (never colored) candles for soft, romantic lighting. Silver or crystal candlesticks are beautiful in candlelight.

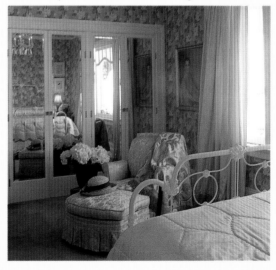

A bedroom must be more than just a nice room with a comfortable bed. On this page we examine and discuss some of the intangibles of good design.

Asleep or awake, we need our bedroom to be quiet, comfortable, airy, well-organized, and very functional. And that's just for starters. It must also be cozy in winter, cool in summer, with clear, filtered light during the day and adjustable light at night.

San Francisco interior designer Michael Tedrick believes that while balanced design is important, good ventilation and morning light are high on his priorities in any bedroom. He also likes corner bedrooms with light on two sides — so that the views are varied and the quality of light is bright and pleasing all day. If the bedroom is in an apartment and can't be remodelled, a tall, window-like mirror in a wooden frame can give a sense of a second window.

Tedrick, known for practical but romantic design, shares his thoughts on bedrooms.

MALE MYTHS Tedrick said it is a misconception that men don't care about the details of bedroom decoration. "It's also a myth that men don't like 'pretty' bedrooms," he said. "Men take to beautiful bedrooms with fine linens the way they take to Lacoste shirts and well-worn jeans." Perhaps

that's because good bedding, silky sheets, down pillows, and cotton blankets are comfortable, feel good on the skin, and provide a great night's sleep. "Men and women both like to be pampered, and we all like our creature comforts," Tedrick noted.

WINDOW COVERINGS To screen light and the view without spending a lot of money, investigate simple wood blinds, gauze or lace draperies, and inexpensive matchstick or tortoiseshell blinds, he recommends. Then another layer of full-length draperies can be added for darkening and sound control. If the draperies are custom-made, they can be given an interlining for more body and longevity. Instead of using heavy blackout material, which ruins the fluidity and "hand" of your curtain fabric, he advises adding an extra layer of inexpensive black cotton or Dacron. Curtains should not be complicated in design. Plain wooden curtain rings and a nice big rod with interesting finials are fine — and they don't add visual clutter.

THROWS/QUILTS Throws can be useful additions to an armchair or the bed. Knitted or woven cashmere throws are the ultimate — at sky-high prices. Fine woven or cabled cotton or wool throws cost

little but do a fine job of keeping your toes warm in winter. Quilts can serve many purposes — decorative and functional. They can start as a bedcover, or be used under the duvet cover for extra warmth. In summer, a cotton quilt may be an instant "slipcover" for an armchair. Wrapping a quilt over a headboard gives a quick new look.

BENCHES A wooden or upholstered bench at the foot of the bed will hold folded bedcovers and extra pillows at night, stacks of books and magazines, a throw or a quilt. A bench will also provide extra seating without taking up much space.

COMFORT Add blissful comfort to an armchair with the addition of a matching cushion-topped ottoman. This versatile combination makes afternoon snoozing or a quick nap a very pleasant experience. When sleep at night is fitful, it's lovely to slip onto the chaise longue and read or write for a while.

VISUAL NOISE If prints, chintz, tartan plaids, or damasks are a passion, it's wise to select quiet, soft, non-aggressive colors and patterns. More than three colors can make a room feel cluttered, busy, and overwrought. However, there's no absolute

rule here. A room with black and white or blue and white toile walls, bedcovers, and draperies can look very chic.

STEREO A stereo system can be a pleasant addition to the bedroom — but controls should either be near the bed or adjustable with a remote control device.

FOOTBOARDS A headboard is essential, especially if reading in bed is a habit. Is a footboard important? Not necessarily, but it does serve several fine purposes. It makes a bed feel important by giving it stature in the room. Best, it keeps out drafts and turns the bed into a silent, private realm.

ANTIQUES Many people use antiques in their living rooms or dining rooms and neglect the bedroom. Too bad. An antique dresser (like the hand-painted Scandinavian beauties shown here), vintage lighting, comfortable antique occasional chairs, faded antique carpets, and splendid old bronzes and heirloom sculptures give a bedroom grace and soul. Old prints and vintage photographs give visual delight.

OPPOSITE Muted colors: Subtle cream, pale blue, and soft green tones merge in this bedroom in a recent San Francisco Decorator Showcase. Design: Tedrick & Bennett, San Francisco.

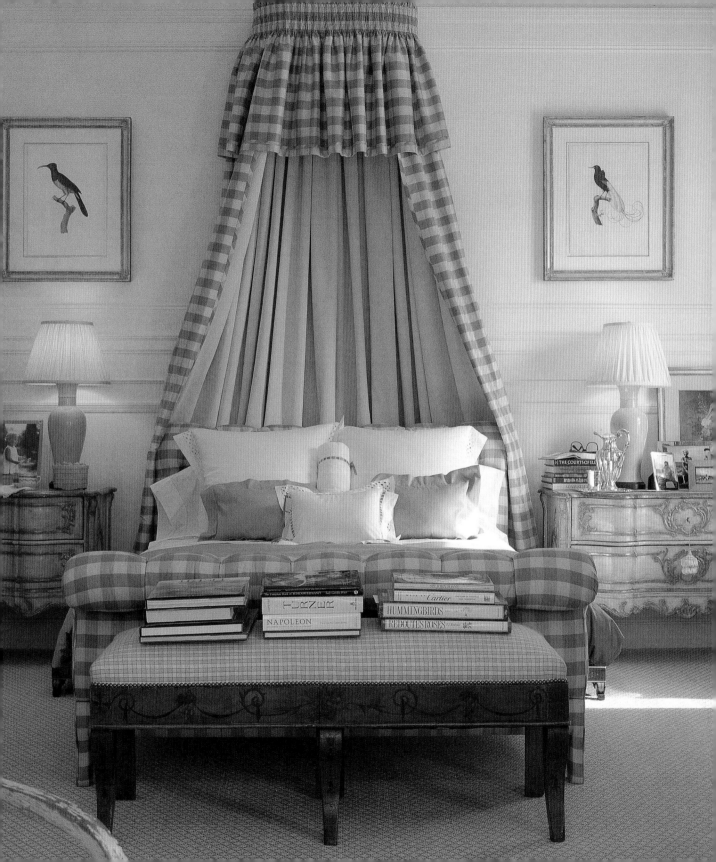

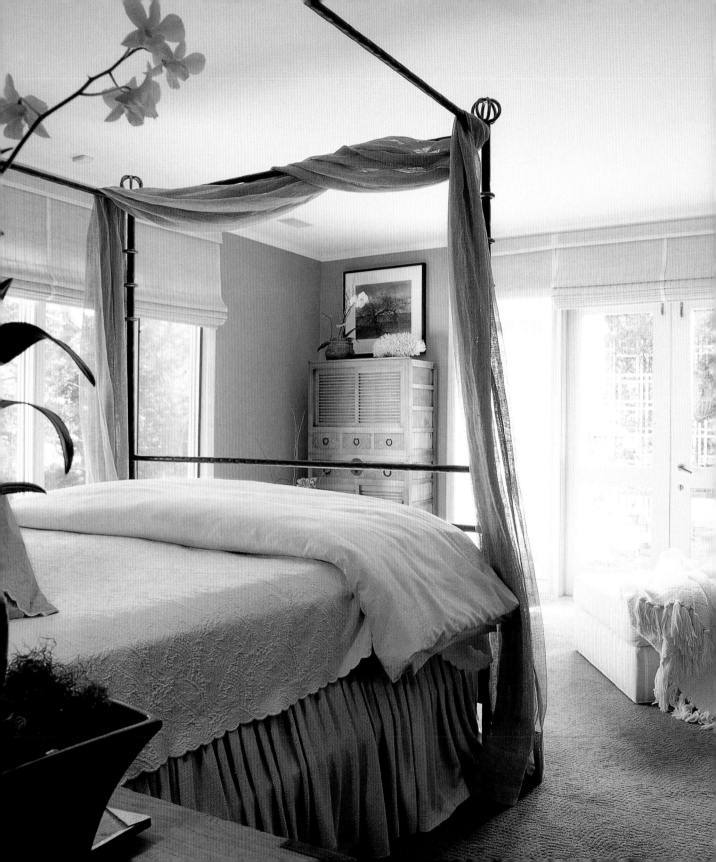

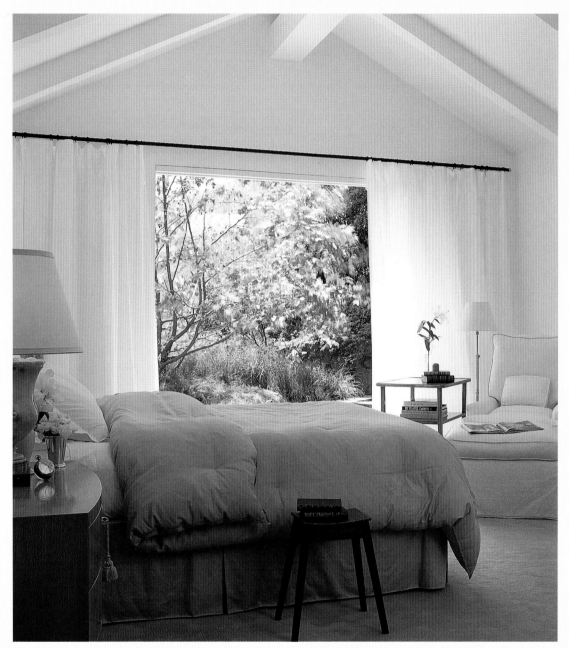

OPPOSITE Created with a touch of fantasy, this bedroom proves that a small room may be magical. Design: Jonathan Straley.

ABOVE Nothing could be dreamier – or more classic – than this Los Angeles bedroom designed by Kerry Joyce.

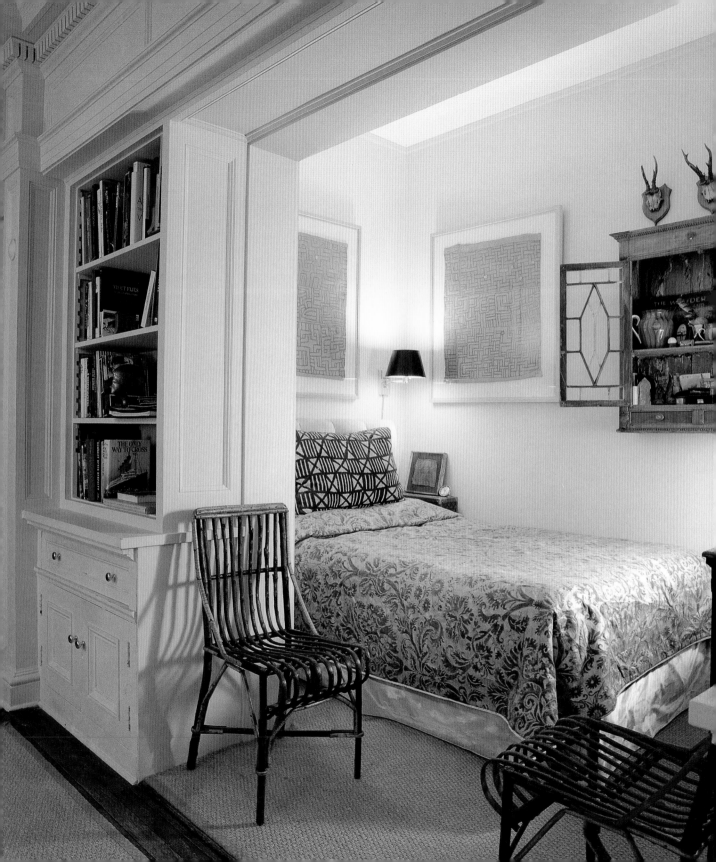

BIG IDEAS FOR SMALL ROOMS

Opinionated ideas for getting the most out of small rooms. Give your imagination free rein — and daydream a memorable bedroom.

Carefully planned, a small bedroom can be luscious, comfortable, and quite versatile. The bedroom may be small but it should nevertheless offer a lot. Even a minuscule room can accommodate the pleasures of resting, reading, writing letters, sewing, cardplaying, and daydreaming.

While some decorators love the visual stimulation of clutter, other designers suggest that it is best to keep furniture, accessories, and objects to a minimum. Devising a subtle and soft-spoken color scheme gives the bed, framed paintings, and a wall of books pride of place.

There is no right or perfect way to formulate a small room, so it's wise to take an open-minded and imaginative approach rather than lean on design "rules." While some designers brighten and lighten (and magnify) small rooms with white or off-white, others turn rooms into tiny, magical jewel boxes with rich color schemes, atmospheric lighting, and sensual fabrics. Conversely, many designers believe a muted, monochromatic background (think taupe, cream, bone, pale fern green) gives the most choices in decorating a small space.

When redecorating a small room, experimentation is de rigueur. For example, a small bedroom overlooking a sunny garden terrace could be given a beautiful wash of wall glaze in golden yellow, the color of a Tuscan afternoon. Woodwork could be painted satiny white. The floor might be practical waxed ebony-stained oak planks, left bare or covered with a sisal carpet. The simplest, chic-est white cotton or washed denim draperies will complete the room.

Cooler colors, such as lichen or palest periwinkle, might keep a sunny room from feeling overheated.

Bed linens for a dreamy small room could be pure white unembellished cotton or linen or heirloom embroidered linens. An armchair slipcovered in off-white heavy-weight washable cotton canvas or washed denim can complete the happy combination. Black and white photographs and prints framed in plain square wood and ebony frames have a graphic presence on the walls.

To give a tiny room more distinction without overcrowding, emphatic architectural details such as wide baseboards, chunky crown molding, or bolder window frames fool the eye and seem to give the room heft and stature.

In a little room, the scale of every piece of furniture, each pillow, has to be carefully considered. Tiny furniture may diminish a room's apparent size, giving it a skimpy feeling. Furniture can be generous, overstuffed, and inviting. In fact, roomy chairs, a big armoire or dresser, and a high headboard always add

ABOVE Small but perfect: A wall cabinet and wall-mounted lamps save precious space. Kuba cloth graphics are hung high to enhance a sense of space.

OPPOSITE Barely a room, Michael Tedrick's sleeping alcove is rich in Fortuny fabrics, wall-mounted collections, sculptural wicker chairs.

scale and dimension to small quarters. Bigger furniture is also more versatile. Two may share.

Buying just a few fine pieces instead of a lot of inexpensive furniture is better for the budget. A little room may still accommodate a well-stuffed sofa and chairs to snuggle in. Slipcovers make chairs feel more relaxed, less uptight. Wall shelves of old leather-bound books, and a pair of wall-mounted swing-arm brass reading lamps beside the bed save floor space.

Small rooms can still be versatile. A 36-inch-round table can easily seat two people for a game of cards. With a pair of folding cane chairs, candles flickering in every corner, and the table set for a late supper, the small room feels very welcoming.

"You have to throw out rules with small rooms," said Tiburon designer Ruth Livingston. "Some interiors call for delicate furniture, others need gutsy shapes and bold strokes. Often the best move is to do the unexpected. In a contemporary apartment, contrast the clean lines with somewhat elaborate antiques. The juxtaposition of honest Craftsman architecture with edgy contemporary art gives a room distinction. Small rooms can be so welcoming. It's best not to be timid. With small rooms you really must take bold steps."

OPPOSITE Designer Douglas Durkin's bedroom scheme: a pristine white background, a sliver of metal bed, comfortable chairs.

BELOW Andrew Virtue's bedroom offers delights to seduce the eye and touch. Edited, arranged "clutter" prevents overcrowding.

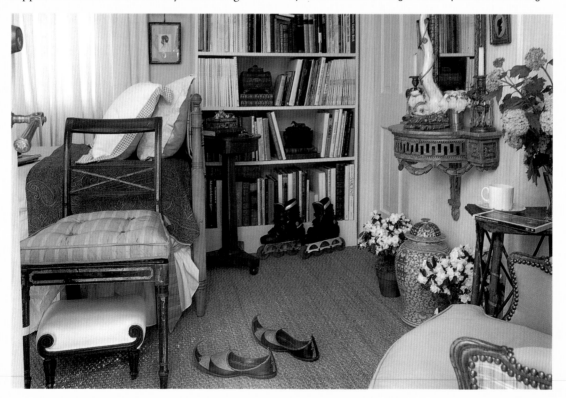

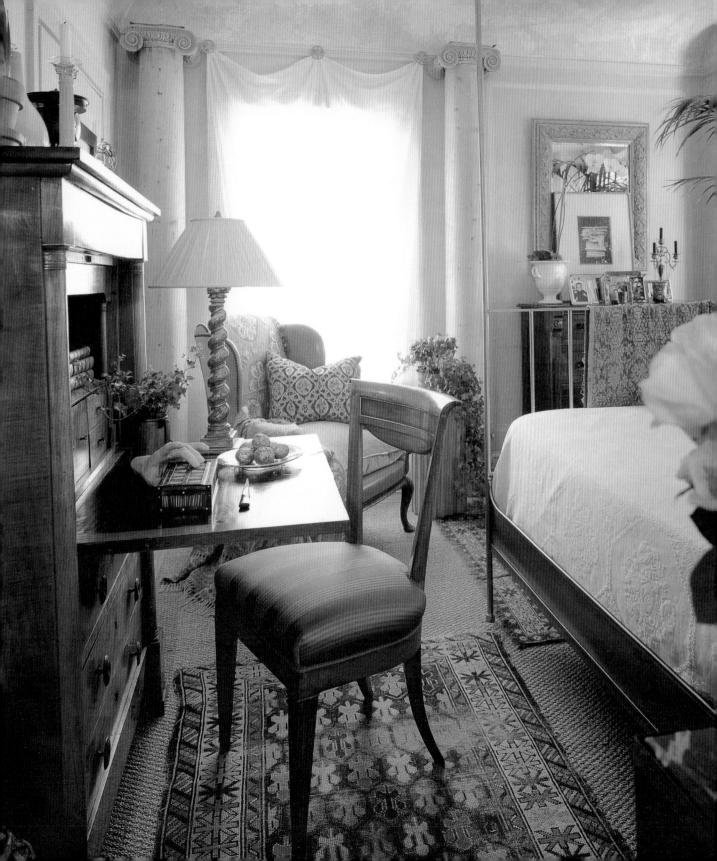

DOUBLE-DUTY Versatile furniture arrangements are a must. A small bedroom can serve many purposes. A 2-foot-by-3-foot table can be used as a desk, a dining table, or console table. Furniture arrangements should not be static. Chairs move; tables are at your service.

ILLUSIONS A large, framed mirror will double the apparent size of a room. Hang it above a dresser, or stand a full-length mirror against a wall. An ornate mirror (gild it yourself) will instantly add a sense of luxury.

STRICT EDITING Good small rooms require a great deal of editing. Don't clutter the room with tiny tables and chairs. Choose bold vases, candlesticks, or big wooden bowls of potpourri over scores of ditsy objects.

"INVENTED" SPACE Well thought-out small rooms can have "rooms" within the room. Plan several seats, lots of wall shelves, a dressing table/desk/computer table with a chair, so that everything doesn't revolve around the bed.

SOFT EDGES Make the room ambiguous with soft lighting, voluminous draperies, or subtle wall colors.

RELAXED Generous draperies, old rugs, antique bed linens, chair slipcovers help a small room feel more relaxed.

USE THE WALLS Take lamps and bookshelves up on the wall and off the floor for a less cluttered look.

KEEP IT FRESH Gleaming waxed hardwood floors are an instant room picker-upper. For some rooms, bleaching the floor will freshen up the decor. For other small rooms, an ebony finish will bring an elegant, timeless feeling.

FABRICS Patterned fabrics in lively hues can bring snap and crackle to insipid rooms. There are no rules: Trust your eye. Sunstruck Provençal colors may wake up some rooms, while elegant, pale geometrics or oyster silk velvet upholstery with crimson silk velvet pillows will flatter others.

ARCHITECTURE Adding architectural interest gives drama to a nondescript small room. Hardware-store crown moldings, salvaged wall sconces, vintage window frames, or a handsome paneled door or gilded mirror from a demolition yard will make the room feel more interesting — and certainly more important.

OPPOSITE Multistripes and checks give this bedroom snap and crackle.

LEFT A striped chair brightens an awkward corner. Designer: Stephen Shubel.

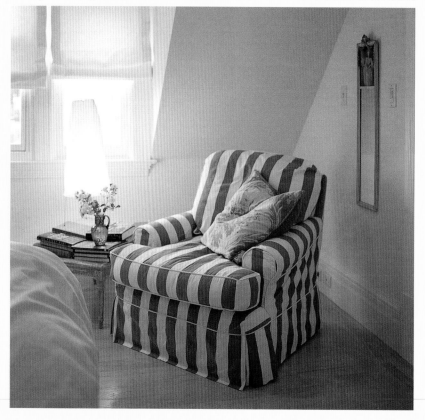

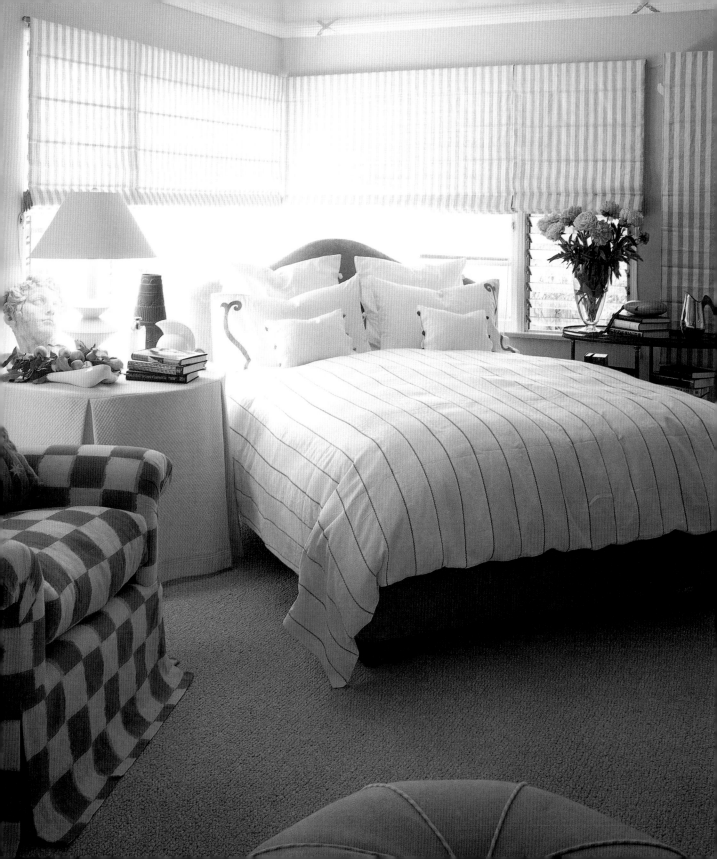

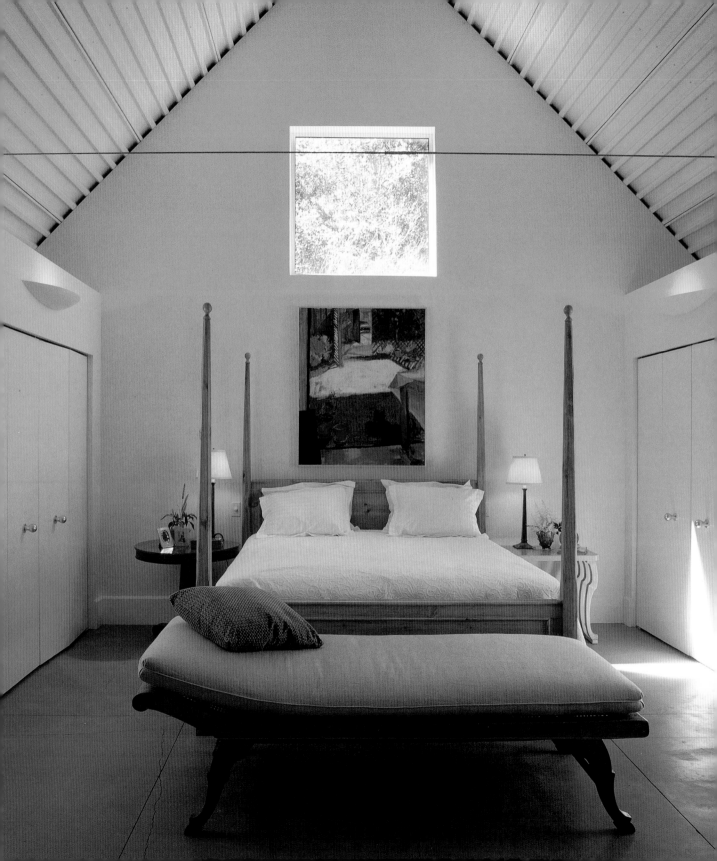

CHOOSING A GREAT BED

Selecting the dream bed — whether grand old brass bed, four-poster, or spiffy new one with a tufted headboard.

Before the new mattress has been given a few test bounces, the sheets have been selected, the down comforter has been mail-ordered, it is time to address the bed. This will be the largest piece of furniture in the bedroom (unless it's a tiny twin bed and the armoire is gargantuan), so it must be beautiful and practical.

Old iron beds, wrought-iron beds, and brass beds are wonderfully romantic, but there are some caveats. Their sizes may be awkward — not standard — and they may be rather squeaky. They may also need to be widened to accommodate today's larger mattresses. (Most mattresses are between 8 and 10 or 12 inches thick — some are even fatter.)

Four-Poster

The many variations on this theme are a great favorite of interior designers. They can be dressed with velvet and chenille draperies in the winter, and draped with gauze and linen curtains in the summer. In fact, four-posters can be styled and restyled endlessly from one year to the next. They can also be left undraped, so that the posts have an abstract, airy quality. Note that some four-posters are merely posts, while others have strong bars on which to support draperies. The best curtains are those that can be pulled around the bed. Skimpy fixed draperies — made to hang at the corner — look fake and rather stingy. But with the draperies drawn and swing-arm lamps drawn closer to offer light for reading, the four-poster becomes a room within a room — very seductive. (Be circumspect about the four poster's dimensions: Reject ceiling-scraping posts.)

Height

Beds can be as high as 36 inches off the floor, especially if it means better viewing of the garden or surrounding scenery from this high perch. Many people prefer high beds to low beds. Being too close to the floor — and being face to face with drawers and shelves and chairs — is not restful. For most bedrooms, a mattress-top height of from 28 to 32 inches is about right. High beds, however, can take over the room and look very imposing and boxy. They need a generous bed skirt.

Daybed

A sleigh bed — with swooping headboard and footboard — can be pushed on its side against the wall and styled like a daybed. Pillows piled along the wall serve as cozy backrests. A tufted sleigh-style bed — with curvy head and accentuated foot — would look like sculpture in a bedroom.

Metal Beds

New or old, they often have to be braced to prevent them from being wobbly, shaky, or creaky. It's impor-

ABOVE A finely delineated iron four-poster with baldacchino.

OPPOSITE This handsome Shaker-spare bed was ordered through the Pottery Barn catalogue. Design: Gary Hutton. Architect: Jim Jennings.

tant, too, to plan plenty of pillows. Metal headboards (especially when the metal is simply bare) will not provide great comfort and can be very cold.

Headboard

Manufacturers are now offering headboards in such materials as bamboo and cane, rolled steel, beech, maple, oak, anigre, cherry wood, upholstered hardwood, pine, and wrought iron trimmed with brass. One of the most modern looks for headboards is a simple linen-upholstered headboard with a tailored slipcover. The slip cover — which buttons, ties, or zips on and off — can be changed for washing and for the seasons. A washed natural cotton canvas slipcover will fit in most bedrooms — and gives a relaxed but very finished look to the room. A wardrobe of headboard slipcovers can be devised with pale floral chintzes, a

simple blue and white striped cotton for summer, and taupe or sage green raw silk with self-covered buttons for winter. If the bed will stand in the middle of a room — or is viewed from both ends — upholstered headboards and footboards are best.

Construction

The best beds are extremely stable. In a wooden bed, the legs and head are bolted to reduce friction and keep the bed firmly on the floor. Before buying, look beneath the bed — especially if the headboard or sides and foot are upholstered. Test the pitch of the headboard. A straight-up headboard will not provide back comfort for reading.

OPPOSITE Country charm: Laura Dunsford's Calistoga bed was improvised from four old wood columns. Ralph Lauren bed linens.

BELOW A classic bedroom by Thomas Beeton, Los Angeles.

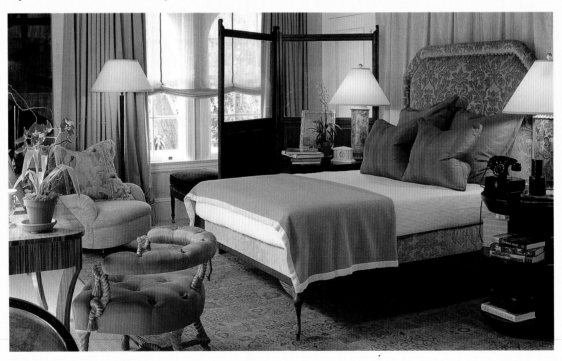

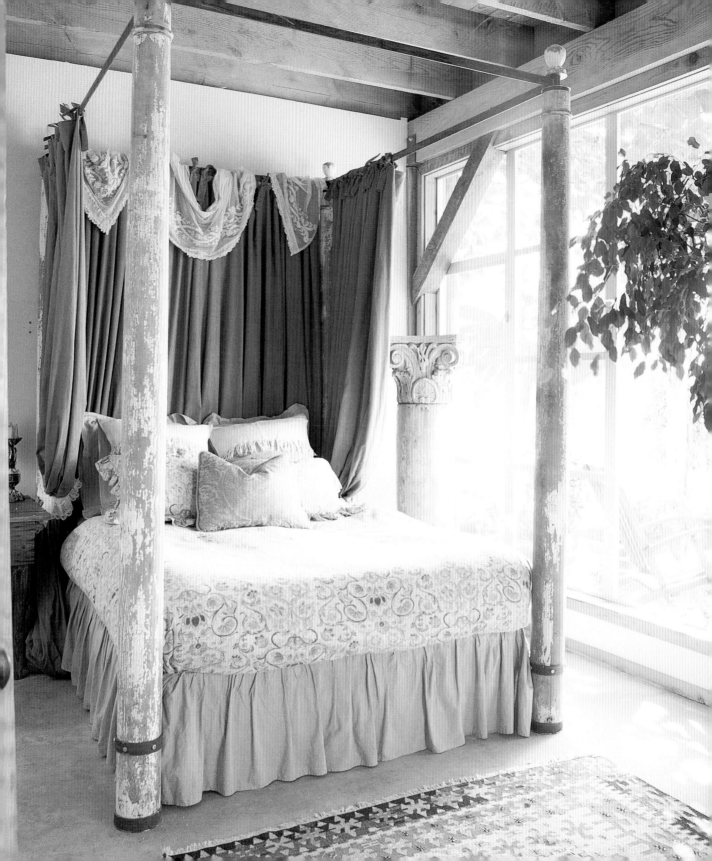

The mattress is the most important single thing in the bedroom. It is here that we read at night, propped up on pillows, and it is here that we spend up to a third of our lives. On the mattress we snooze, convalesce, make love, daydream, play with our children, nurse the baby, chat, and snuggle. The mattress must be up to such important and life-affirming tasks.

PRIORITIES It's wise to select the mattress before choosing the bed frame, the headboard, and all of the bed linens. While the bed "dressing" is important, the comfort and appropriateness of the mattress is paramount. Mattresses vary in thickness, too, and some super-padded mattresses may not fit an antique bed or a simple Mission-style wooden bed.

SIZES The measurements of the bed may be restricted and governed by the size of the room. For one or two people, a queen-sized bed usually works best, but some partners love the snug fit of a double bed. A king-sized bed sounds grand, but professionals say the large size often looks ungainly and overwhelming in a bedroom. But for those families that like to breakfast in bed, read Sunday papers in bed, or snuggle up

and watch TV or a video together, a king-size may be perfect.

DIFFERENT NEEDS When two people sleeping together like or need different kinds of mattresses, there may be a way of pleasing both. Two twin-sized or double beds (of different densities) can be combined beneath one "pillow-top" mattress pad.

MEASUREMENTS Taking careful measurements of the room before purchasing the mattress and bed frame will prevent nasty surprises – like discovering that the bed length or width will not fit along a narrow wall, between two doors, or along a side wall as planned.

TOP-NOTCH It's budget-wise to buy the best mattress that fits the pocketbook. It's definitely worth looking at the very best mattresses available – to compare quality and see what might be lost by spending less. The very finest mattresses, which will last for a lifetime, are custom-crafted, and entirely handmade. The heavy-gauge steel springs are hand-tied, and the stuffing is in thick layers of natural fibers. The edges and the buttons are all hand-stitched. (Some shoppers also check that a fine mattress is free of formaldehyde and fluoro-

carbons, said by some to emit harmful gasses – check with the manufacturer.) But some off-the-rack mattresses come close in comfort and quality.

SPRINGS Is a box spring really necessary? It's a personal choice – and sometimes an aesthetic one. Padded box springs add to the comfort and cozy feeling of a bed. Placing the mattress directly on the slats of a bed frame gives it a firm base, and gives the bed a spare, understated look.

STYLES There are so many different styles of mattresses that it is important to look at a broad selection. Mattresses and beds like those made by Dux, for example, have unique construction and a comforting, pillow-y mattress topper. Dux stores encourage customers to slip off their shoes and try each bed. Other mattresses go all the way from extra firm to squishy, soft, and foamy, with broad variations in price, construction, and materials.

EXTRA COMFORT Even the best mattress can be made more comfortable – and durable. Stores and catalogues now offer a wide range of pillow-top pads and mattress pads (plumped with cotton, wool, or synthetic fibers), along with cozy merino-wool fleece mattress pads, foam

(not especially long-lasting), cotton-pile chenille (durable and soft), and even down-filled and silk floss-filled pads. Some sleepers find the ultimate cushioning with a feather bed – a down-and-feather-filled pad that is inches thick and extremely supportive. (It's sensible to check that fitted sheets will fit over both the pad and the mattress before purchasing the feather bed or an extra-fluffy plush wool pile pad.)

CARE To keep the mattress in tip-top shape, it is best not to sit on the edges. Keep a chair near the bed. Mattress protector sheets and pads of varying fabrics will protect the mattress from spilled tea and other mishaps of breakfast in bed.

FUTONS While not strictly classified as mattresses, cotton and wool futons serve as very comfortable sleepers for many space-conscious people. Usually made of stitched cotton batting, or available in wool, the futon can be draped over a frame to form a chair or a sofa during the day, thus saving space. Construction should be somewhat firm so that the batting is not loose or lumpy.

OPPOSITE Doug Biederbeck's custom-made four poster holds pride of place.

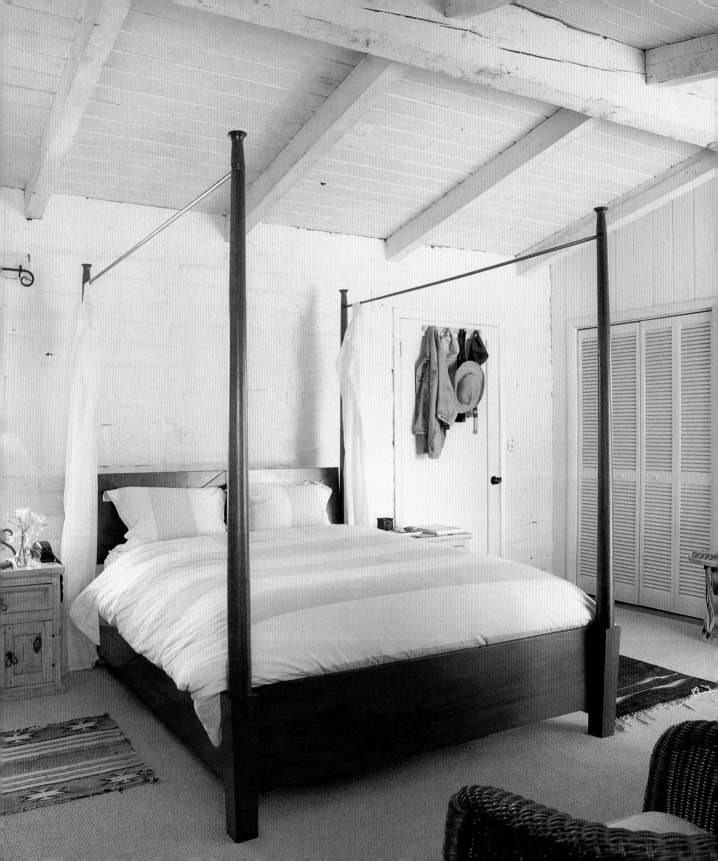

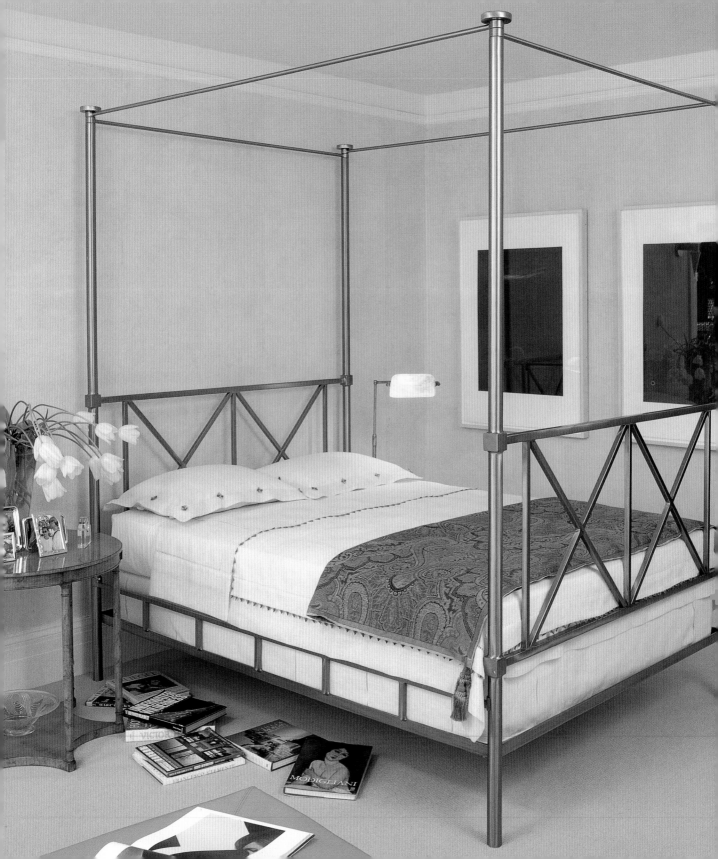

A WARDROBE OF SHEETS

Beautiful sheets will last a lifetime. So buy sheets for all four seasons, for special occasions, but mostly for style.

An old English motto says, "You should have at least three sets of sheets and pillows; one for the bed, one for the linen closet, and one for the laundry."

Personal Style

Forget sets and matching everything on the bed. Sheets and pillowcases and shams and bedcovers don't have to match — so styling a bed today can be the ultimate please-yourself project. A joyful and pretty springtime bed can combine a variety of floral patterns on shams, the duvet cover, and the top sheet — none of them matching or coordinating. Or a bed can be dressed in shades of blue — with plain periwinkle blue sheets and striped or plain blue Oxford-cloth pillows with white piping, plus a white *matelasse* coverlet. Neither do the fitted sheet and top sheet have to match. One may be striped, the other plain — the top sheets could be a pink and white rose-and-ribbon pattern, and the bottom sheet a plain pale pink. Floral sheets can mix with plaid blankets, mohair covers can wrap white linen sheets, and pillow shams of vintage silks or old tapestry can happily live with cozy white flannel sheets.

Colors

Yarn-dyed sheets (in which the yarns are dyed before weaving) will generally keep their color best. Applied patterns or piece-dyed sheets (the color is added to white sheets) may fade somewhat eventually.

White on White

The joy of an all-white bed is that there are no colors to tire of and no pattern to clutter the bed. Whites don't have to be all the same style to look crisp and pristine. An all-white ensemble can be created with both new and heirloom sheets and shams — and a mix of plain, jacquard, damask or embroidered pillowslips, sheets, shams, and bedcovers. With an all-white bed, you can add texture with *matelasse* quilted bedcovers, with honeycomb-style blankets, and with off-white lambswool, mohair, merino, alpaca, silk, or knitted cashmere blankets.

Lace

Hemstitching, scalloped embroidery, and lace trim should be examined before purchasing. There are many different lace edgings and trims on sheets today. Some are extremely durable and well-stitched, while others are stiff, or as filmy as a spiderweb and even less likely to withstand washing. And don't forget monograms. Just be sure the script or lettering is classic — not cutesy or curly. Roman lettering or simple shapes will look better over time.

Luxury

Many catalogues now offer not only pure white linen sheets (once an old-fashioned rarity), but also linen and cotton, cotton and silk, and silk sheets in classic jacquard woven designs. One advantage of linen is that it is an extremely durable natural fiber. It also feels deliciously cool on a warm summer night. While

OPPOSITE Neatly arranged, these chic bed linens invite repose. Note the subtle touches – buttons, scalloped edging, a beautiful corded throw. Design: Jula Sutta.

some manufacturers suggest that linen and silk can be machine-washed and line-dried, it generally feels and looks best if it is sent to a French laundry, where giant mangles smooth the sheets and give them the best finish. Italian silk sheets (usually available in pale ivory) are also delicate but very durable. Store fine linens and silks in protective muslin bags in the linen closet. Lavender sachets will keep sheets smelling fresh.

Weaves and Fibers

Where once there were only one or two types of woven fabric and several types of cotton available for sheets, today the choices seem endless. Choose the most tactile and the one that offers the best value. Pima, Supima (100 percent Pima) long-staple Egyptian, undyed and unbleached eco-correct cotton, and twill weaves, sateen, plain, and damask are all perfectly practical. It's a matter of personal taste.

Facts

It's now common to see sheets with from 200 to 590 thread counts. The thread count is measured by adding the warp ends per inch and the filling picks per inch of the woven fabric. Generally, the higher the thread count, the silkier and lighter the sheets. But the appearance and feeling are also affected by the quality of the cotton and the finishing processes. For everyday, 200 or 250 is practical and often quite luxurious – if the sheets are Egyptian cotton with no chemical finishes. No-iron, no-wrinkle finishes tend to make even good cotton sheets feel like polyester. Check on labels for descriptions such as "pure finish" to select sheets that will feel like cotton – not synthetics. Before purchasing, feel the cotton.

A B O V E A neat, modern way to dress the bed: simple, fine cotton sheets with a white cotton duvet cover.

O P P O S I T E Wall-mounted lamps that can swivel are ideal for those who love to read in bed. Design: Sudie Woodson.

Don't expect just one bright light to do everything. To get the most restful and versatile lighting, consider layering.

AVOID Stay away from ceiling lights – especially a central light. Take care of general illumination first. While one bright overhead light may seem practical and functional, it's probably too harsh for a bedroom. It's also very unflattering, and won't illuminate specific tasks, such as applying makeup, reading, or writing letters at a desk.

LAYER "Layering" lighting makes a room much more functional, friendly, personal, and interesting. Layer lights by choosing two or three different sources of illumination. For example, in a large bedroom, a decorative floor lamp, a decorative overhead light, a table lamp, and a pair of wall sconces or a torchiere – all on dimmers – could be chosen to give character, multiple moods, and variable light. One or two bedside table lamps, plus a desk light or sconces, offer basic, general lighting for most small bedrooms.

TASKS Always take specific task lights into consideration when planning lighting. Halogen desk lights, vanity lighting, wall-mounted swing-arm reading lights beside the bed, flexible under-cabinet lights

and decorative table lamps will put the best light right where you need it. Adjustable desk lights that swivel, bend, or stretch are a better choice than fixed ones. The classic black "Tizio" lamp by Artemide is a versatile, practical choice. The acclaimed original design is now also available in a new smaller size, in black and in white.

SPOTS Consider adjustable ceiling-mounted accent lighting to highlight a bookshelf, a writing desk, art objects, paintings over a mantel, or flowers. Choices include recessed lighting, track lighting, low-voltage lights, or low-voltage cable wire systems. Small individual mono-point lights, easy to install, stand on mantels, desk, or floor, and may be all you need for one painting. Easiest of all are small portable plug-in accent lights that can be concealed behind furniture.

TABLE LAMPS When your basic lighting needs are planned, look for small, decorative accent table lamps. The classic paper-shaded "Akari" light by Isamu Noguchi works well in both contemporary and traditional settings. Innovative lighting designs by Ron Rezek, Ingo Maurer, Philippe Starck, and Andree Putman are excellent choices for warm, ambient lighting with contemporary personality.

COLOR Hand-blown glass light shades in tones such as ecru, amber, rich cream, peach, or white are flattering to furniture, mood, and people. Clear blue or green glass tends to make a room feel cold.

DIMMERS All permanently installed lighting and halogen torchieres should have dimmers to control light levels. With a dimmer control, it's possible to create many different lighting moods. An electrician can change existing switches to dimmer controls.

TECHNOLOGY New improved technology for more convenient lighting includes hand-held remote controls for dimmer systems; pre-sets, which adjust one room or the whole house to different

lighting moods with just the touch of a button; energy-saving lamps; compact, color-improved fluorescent lamps; versatile energy-efficient screw-in fluorescent lamps. Improved halogen lamps are light years ahead of the first-generation lamps, and give off more light-per-watt to save energy.

CANDLES A pair of beeswax candles in silver candlesticks on a mantel, or a simple beeswax pillar candle on a bedside table offers serene, comforting lighting. Scented candles can be soothing; just be sure the fragrance is not overpowering or too sweet. Traditional natural (not synthetic) lavender, rose, fig tree, or tea scents will please most noses.

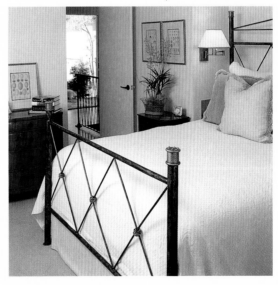

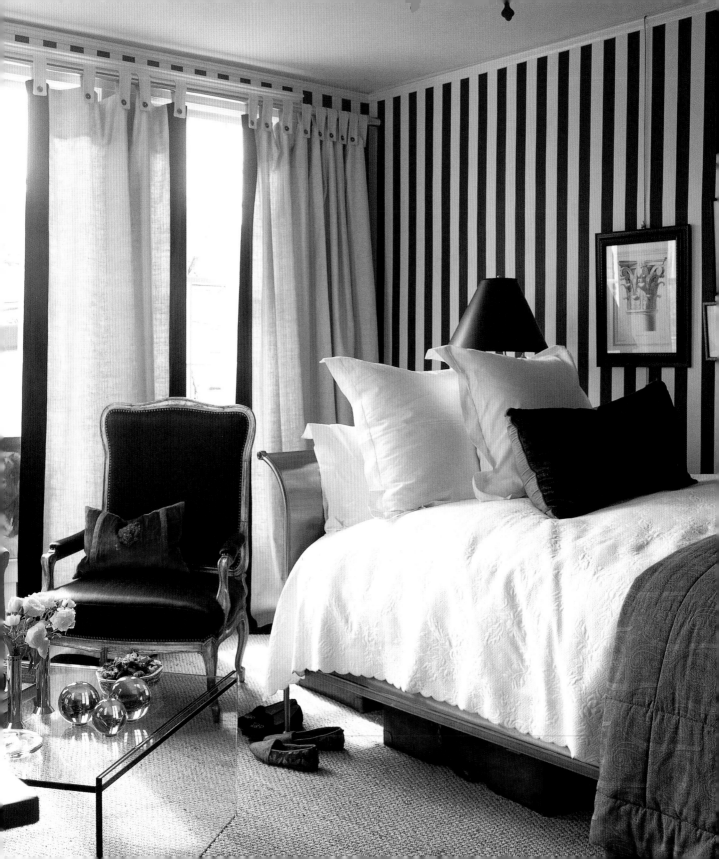

UP ON DOWN PILLOWS & COMFORTERS

Down-filled bedcovers and pillows, once rare and expensive, are now
almost standard bed dressing, especially in winter.

Pillows

Soft and supportive, squishy and malleable, down pillows and down-and-feather pillows have now replaced hideous hard foam and unforgiving synthetic-fiber pillows in our affections. Even those who are allergic to feathers or down can now find pillow-protectors to keep feathers where they should be — before resorting to synthetic down-like fiber pillows.

While stores sell down pillows in densities from soft to medium to firm, most specialty stores and bed linen catalogues offer a panoply of pillows. Good pillows have a high down fill power of 550 to 650 (more light, white, fluffy down in the fill and more resilient "bounceback") and have an Egyptian-cotton 260-thread-count (or more) ticking. Other options include a feather and down mix (somewhat firmer) and all-feather pillows, which are somewhat crunchy and firm and most ideal as back support for reading in bed.

Catalogues and specialty stores also offer a broad range of custom-made pillows — from down-filled standard pillows to extra-firm feather-filled pillows that make perfect watching-TV-in-bed pillows. There is every possible permutation on the pillow, from tiny to fat king-sized, and every dimension, from rectangular to European square to rolls and bolsters.

The finest pillows, puffed up with at least 650 to 750 fill power of white European down, and with a 300-thread-count combed-cotton cover (standards usually cost around $90 to $100), should last for many years with good care. Ultimately, however, the choice is personal. Some people sleep best on a firm goose-feather-and-down-filled pillow that can be shaped and pummeled to the perfect contour. Others find sublime comfort on a lofty cloud of soft, pure down.

Manufacturers recommend buttoning or zipping a cotton pillow-protector on each down pillow. Plumping a down pillow every morning, and airing it in a sunny window at least once a week will keep it fluffy and comfortable. Having the pillow professionally cleaned once a year and occasionally replacing the cover will ensure its longevity.

Comforters (Duvets)

Down comforters, beloved of English grandmothers, are now warming the toes of chill-averse sleepers everywhere. They're light, extremely durable, and give a friendly contour to the bed. It's the plumules of down, the silky filaments formed in clusters on the fine quill, that give down quilts and duvets their soft, airy, light feeling. They trap air and provide excellent insulation on even the frostiest nights.

Prices for this wonderfulness vary. It's possible to buy an ultra-light twin-sized down comforter for less than $100, or to pay as much as $1,500 or more for the finest, loftiest down comforter with 350-thread-count cotton ticking. Buying the best down with big, fluffy clusters (fill power from 575 to 750) is generally a good investment. While lighter duvets will squash down into pancakes in a few years, a well-crafted comforter

OPPOSITE "You can never have enough beautiful down pillows," says designer Stephen Brady. *Matelasse* shams and cover: Sue Fisher King.

filled with lots of ultra-light European down will last for at least a decade and stay plump and glorious.

Construction of the comforter varies from sewn-through (in channels or box shapes) to more elaborate karo and baffle-stitching. Each is styled to keep the down from shifting around the duvet.

When selecting the size of a comforter, it is often a good idea to buy a size larger than the bed size. For example, a king-size comforter on a queen-size bed will look plumper and more luxurious and is less likely to slip off the bed on cold nights. It is also more generous for two people sharing the bed. Be sure to buy the larger comforter cover to go over it.

To care for a duvet, it's best to give it a good shake every morning to keep the down evenly distributed. Every week, it should be turned so that the ends do not become compressed. It can also be fluffed in a dryer, following the manufacturer's instructions carefully and keeping heat minimal. After a year or so, duvets can be sent for refreshment (and perhaps cleaning and repair) to a down specialist. They can also have more down pumped into areas that have thinned.

OPPOSITE This down duvet adds luxury to the architectural lines of the bed. Design: Patrick Wade, Stephen Brady.

BELOW The perfect tailored bed: Stephen Shubel designed a simple skirt and a fluffy, white cotton-covered duvet.

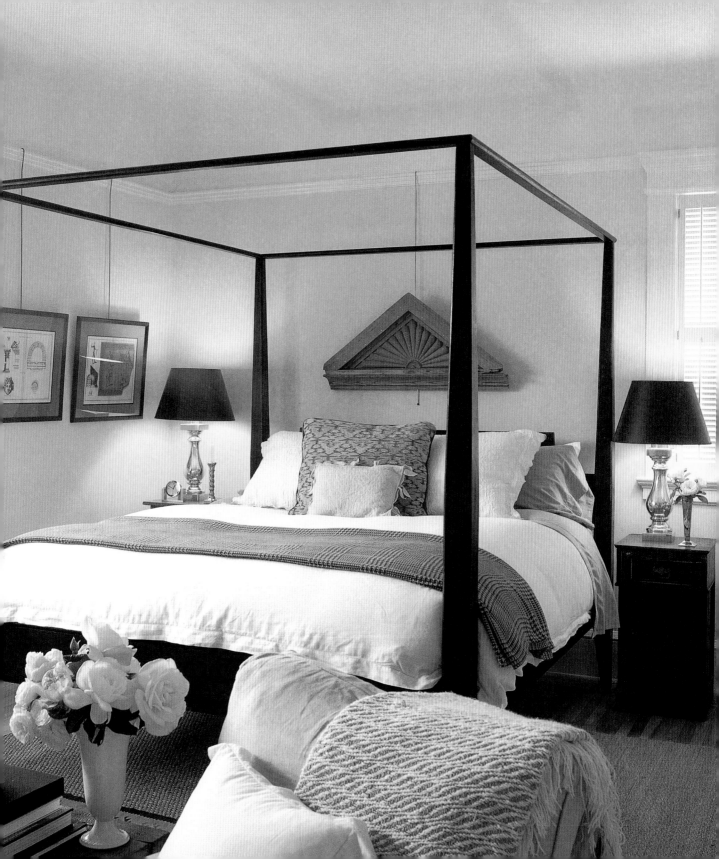

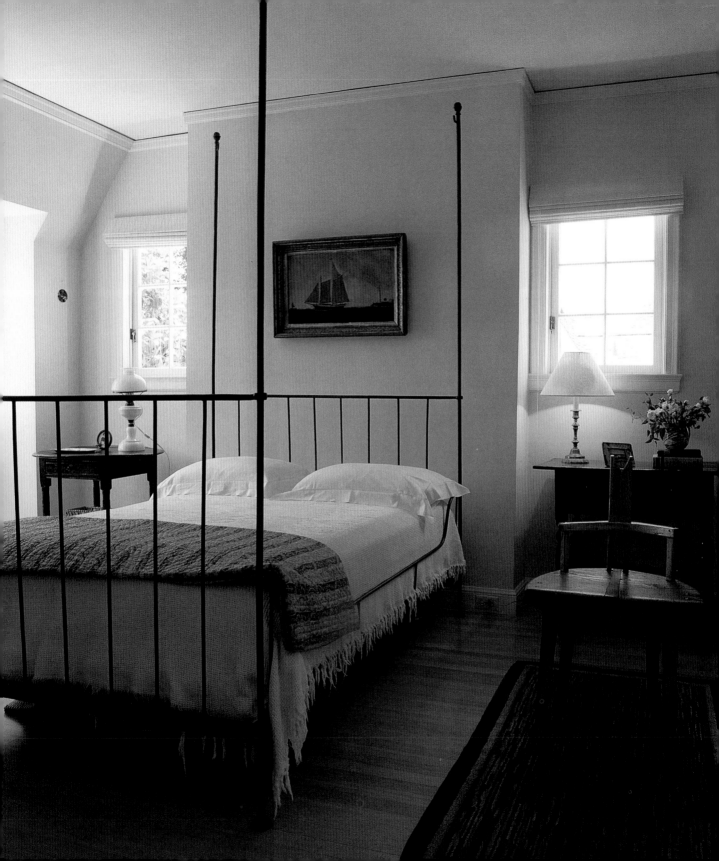

COLOR SCHEMES

Finding a pleasing, calming color for the bedroom walls
may take some experimentation.

Leading international color designers Jill Pilaroscia and her partner, Emily Keenan, of Colour Studio Inc. in San Francisco, are imaginative professionals with inspired ideas. In their professional lives, they open clients' eyes to new color possibilities — and suggest ways of solving design problems with color. The partners use a special interdisciplinary perspective, melding psychology, aesthetics, and ergonomics to create color schemes for both interior and exterior design. Keenan and Pilaroscia also specialize in historic reproduction palettes.

Best of all, the two women of Colour Studio are open-minded, curious, and nonjudgmental about all colors and their effects.

"Of all the rooms in the house, the color of walls in the bedroom requires the most careful consideration," said Pilaroscia. "This room sets the stage for your dreams at night and provides the first visual impression upon awakening. This is where the most romantic encounters can take place — or where you spend fulfilling hours alone. The colors should enhance all of these activities."

Pilaroscia suggested that the bedroom color palette can be envisioned and planned in the same way a writer would develop a story line.

"You first establish favorite colors, then develop the mood to foster the style and attitude of the colors and the room," said Keenan. If the bedroom doubles as an office during the day, for example, colors might be cheerful but not frivolous. If it's simply used for sleep, the room could be painted pure white with no distractions. If it's a room where the family gathers for cozy morning chats, it could be a jazzed up in golden wheat tones or terra cotta with buff woodwork.

"I always ask my clients if they meditate in their bedrooms, and whether they exercise, work, read, or write there. These activities ask for a softer, nonstimulating ambiance," said Pilaroscia. "And daylight should be taken into consideration. If sun pours into the room in the morning year round, it's best to keep walls on the pale side. Pompeiian red and carnelian, which look so handsome in night light, can be so agitating at first bright light of day."

The finer points of the architecture and the history of the building should also be taken into consideration when selecting colors. Often that means choosing a color scheme that feels authentic to the style of the building's interior and its setting. Memorable rooms are also created when you break out of the box of logical thinking, and select tones and color combinations that contradict the mood of the house. Modern colors can jazz up the sober rhythms of an Arts & Crafts interior. Antique colors flatter the contemporary.

ABOVE Witty colors (and art) should never be overlooked for bedrooms. Who says bedrooms have to be so serious?

OPPOSITE Muted hues can be most restful. They are classic and versatile. Design: Eleanor Moscow, Berkeley.

CALM MOOD The bedroom is a place of recuperation from the many tasks and demands of life. While most people would like the bedroom to feel serene, restful, and low-key, not everyone agrees on which hues soothe the soul. The pale sage that cools stress for one weary worker is jarring for another. The white room that offers a blank canvas for an overstimulated banker is boring and bland for a teenager. A tour of the color wheel offers many possibilities – and new hues.

COOL TONES Many color professionals consider colors associated with water and the sky to be relaxing and restful. A pale gray/green, palest aqua, robin's egg blue, and celadon would fit into this color range. Deeper, richer tones of blue

and green can create a sense of mystery and blur the edges of a room, softening the mood.

FASHION Designer Jill Pilaroscia encourages her clients to consider fresh colors like chartreuse, coral, periwinkle blue, lime green, and rich gold – either on walls that will be partially hidden by a large armoire, paintings, or draperies, or as accents. These colors are too strong for large expanses of wall. Insistent colors can become tiresome.

WARM COLORS Red, orange, bright pink, and other warm tones are generally considered to be stimulating. Walls of crimson or apricot will look dramatic, but will not encourage a calm aura. However, pastel renditions of these hues, such as dusty

rose, pale apricot, pale Venetian red, or pastel rose (never bubblegum pink) can feel light and refreshing and not at all aggressive.

NO CONTRAST Often the best way to work with calming color is to keep somewhat within a narrow range – with little contrast between walls, ceiling, floor, bed linens, and furniture. The eye is drawn to drama and contrast, so a low-key color mode will keep the room quiet.

NEUTRALS Neutral tones – from white to cream to beige to taupe and moss – are popular for bedrooms because they are practical and easy on the eye. Pilaroscia said they can often look bland and rather flat. She recommends pushing the color up a notch or two – from cream to wheat, from taupe to mocha, from off-white to Tuscan gold – to make the room more interesting and modern and still keep an understated feeling.

TEXTURE When a room goes minimal and pattern is banned, the best way to add interest to the room is to use textured fabrics, carpets,

OPPOSITE Elegant neutral colors. Design: Barbara Barry.

LEFT Barbara Colvin's bedroom has a dash of green.

paint finishes, and bed linens. Cotton *matelasse* quilts, faded kilim rugs, a quilted headboard, jacquard textiles, ragged or combed paint finishes on the walls, or damask sheets on the bed enrich the room.

INTEGRITY Color pigments mixed integrally into wall plaster give walls a rich finish. It's an expensive and time-consuming way to make a wall surface, but the superb texture and variations in the plaster give a room a dimension and stateliness no paint or faux finish can approach.

HARMONIES In designing a bedroom, no detail of color is too small. Surfaces and textures matter. Shiny or matte? Satin or glossy? Rough or smooth? The harmonies of each color, finish, surface, material, and hue introduced into the room are a delicate balance. The most beautiful rooms are those where colors are composed with perfect pitch and come together like the notes of a symphony. For the ultimate refinement, a bedroom could be designed in several shades of white – or in white with contrasting satin, semi-gloss, gloss, or matte finishes. Sand, buff, or pale camel walls trimmed with linen-white baseboards, molding, and ceiling is another chic tonality.

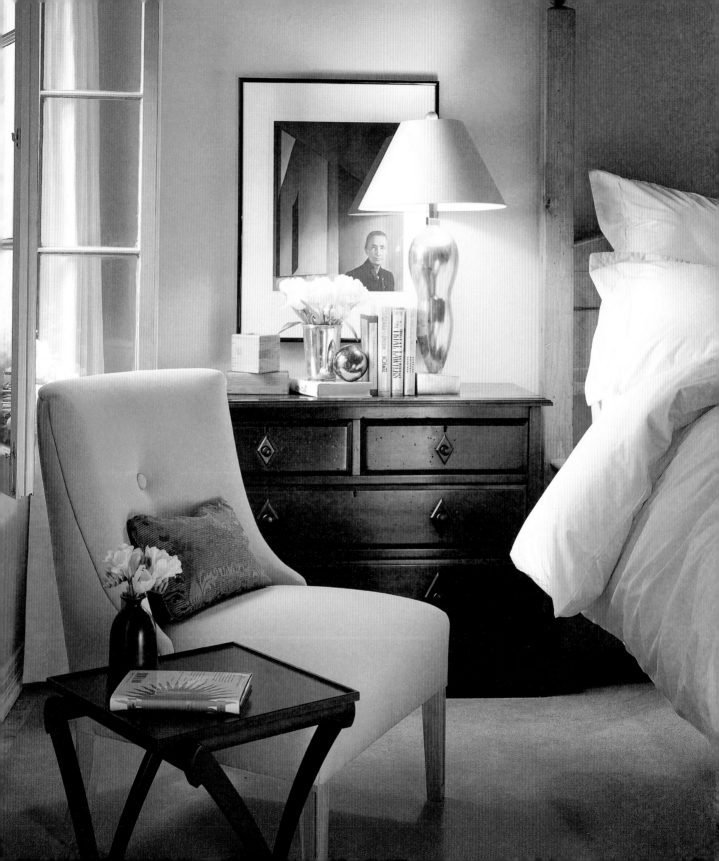

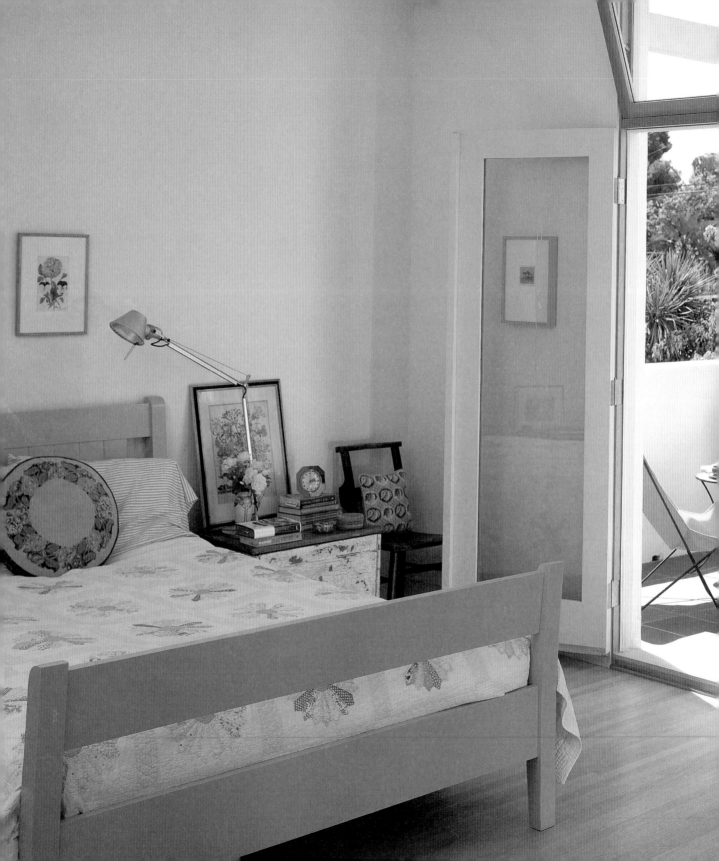

FENG SHUI

Ancient concepts of harmony, balance, logic — and superstition — can help you design a more peaceful, comfortable bedroom.

The highly complex philosophy of Feng Shui (pronounced *feng shway*), first developed in Asia centuries ago, is based on principles of timeless aesthetics, correct placement, and appropriateness. Over time, Feng Shui has become not only a system of beliefs that affect home life, spiritual well-being, health, luck, and happiness, but a framework for living in harmony with nature and the seasons. While some consider the concepts too esoteric or superstitious, others keep an open mind and find that adjusting decor or correctly siting a house will maintain balance in their lives and have beneficial effects.

Today, many homeowners (along with their decorators and architects) are turning to Feng Shui to help them build and design nurturing and pleasing environments.

Some recommendations by Feng Shui experts — such as never to hang a mirror above a bed — make good sense, especially in California where a temblor or quake could dislodge the mirror from the wall. Another Feng Shui tradition is to position bedrooms on the sunny side of the house so that morning light greets the occupants as they wake to start the day. The sun, says the ancient wisdom, gets energy flowing. It's worth trying.

Very old Feng Shui advice forbade positioning a mirror so low that the reflection cut off the viewer's head. This would bring very bad luck. Common sense suggests that mirrors are most effective when they present the big picture.

The Feng Shui recommendation to "soothe" a room by selecting plants with round, floppy leaves

(rather than spiky ones) may be mere wishful thinking — especially if the homeowner does not have a green thumb. For those with a sunny city bedroom, however, the sight of spiky-leaved spring tulips growing in the window can have a very pleasing, uplifting effect.

For bedrooms, there are several worthwhile Feng Shui principles and recommendations for enhancing harmony and comfort. One is to select soothing colors to heighten the feeling of relaxation and repose. Another is to create mostly smooth, soft surfaces with large cushions and pillows, an upholstered chair or sofa, carpets, and tapestries. Sharp edges, hard surfaces, and stimulating colors are to be avoided.

One Feng Shui concept suggests positioning the bed so that the occupant or occupants face the door. Ancient wisdom held that this would prevent surprise visits by an evildoer. Today's wisdom suggests confidence is enhanced when one can see who is coming or going.

Perhaps the best pointer offered by Feng Shui experts is to avoid any kind of clutter in the bedroom.

ABOVE Everything in its place: A painted armoire resists clutter.

OPPOSITE Light, air, and the free flow of "energy" are important to life-enhancing rooms. Architect: Michael Sant, Santa Monica.

Messiness and disorganization are to be discouraged. The flow of Chi energy (life force) will be slowed. Clearly, order makes for a more peaceful, relaxed mood in the bedroom. The occupants won't feel a sense of anxiety when they know where everything is stored. Regular Feng Shui-inspired cleaning sessions to clean out closets and put away magazines will surely encourage the freshest Chi energy.

With Feng Shui in motion, the bedroom cleanup will be therapeutic, and a favorite charity may benefit from discarded clothing. Comfort and order will have been restored. If Feng Shui's goal is to bring harmony, then sprucing up your bedroom will have worked wonders.

Getting started with Feng Shui is a worthy but far from easy path. Common sense and caution must be applied, as different practitioners have sharply divergent viewpoints. One well-known Hollywood actress was strongly advised to place a bright yellow armoire in the room to improve the Chi. This was not an obvious, logical move for her, but she was willing to experiment. Another Hollywood actress consulted a Feng Shui expert, had her house rearranged to "improve" its energy, and found herself very unbalanced by the unfamiliar, uncomfortable placement and off-putting floor patterns that resulted. But others who follow Feng Shui principles report that wind chimes, the sound of running water, new plants, and fresh furniture styling give them new peace of mind and repose.

OPPOSITE Beautiful, calm light and well-balanced architecture give this room good energy.

BELOW This graphic curve of windows bestows a meditative air to this bedroom. Design: Kerry Joyce, Los Angeles.

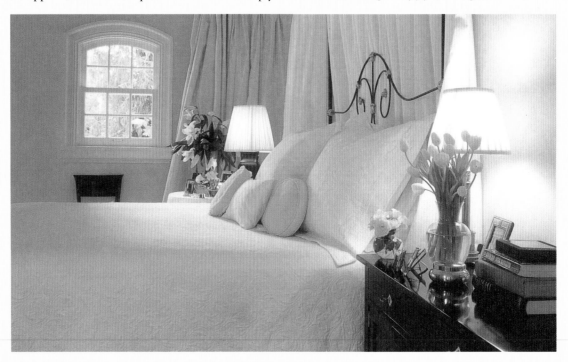

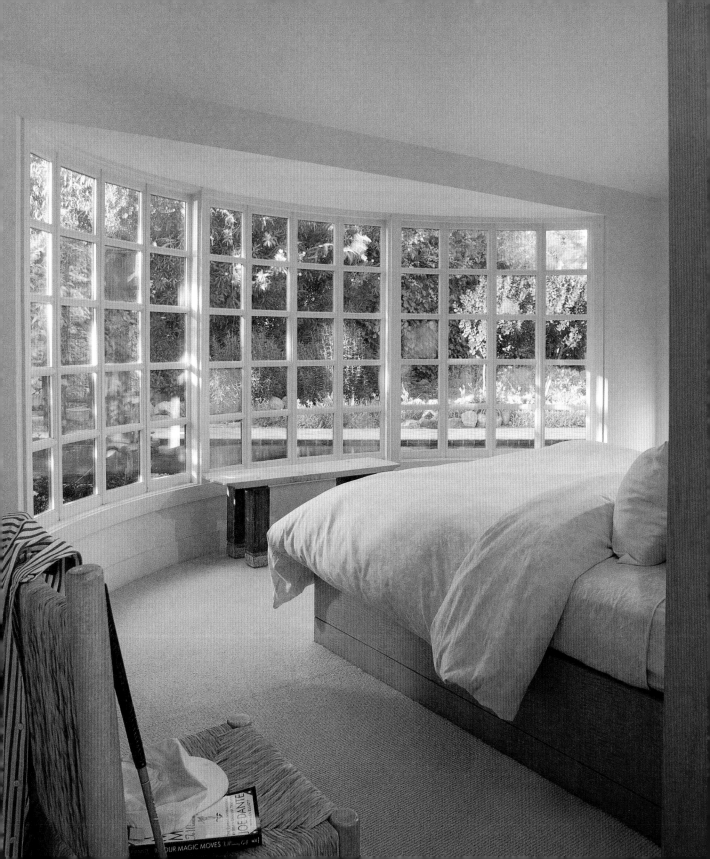

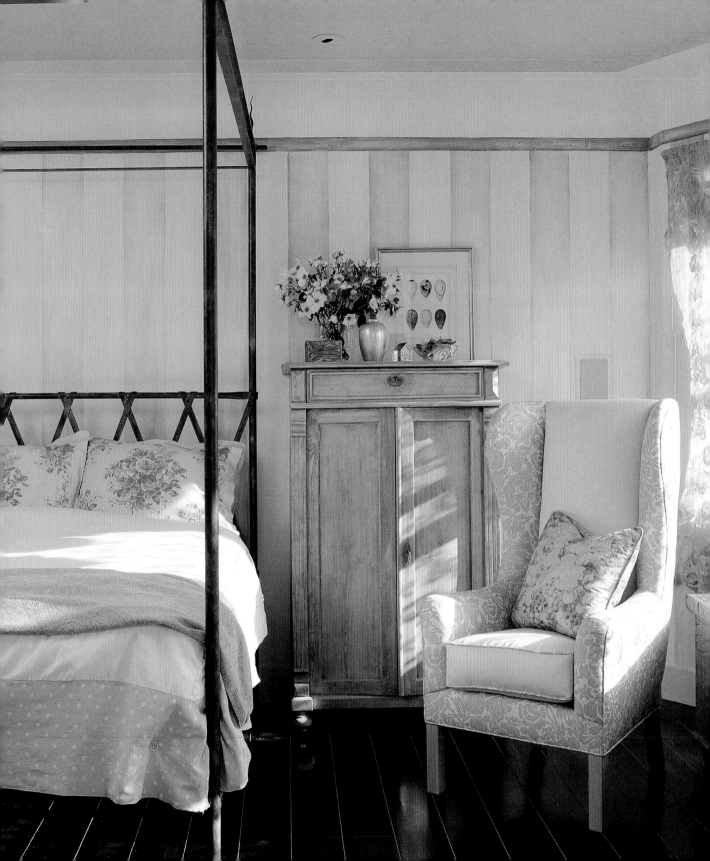

DIAMONDS IN THE ROUGH

Junk-shop bedroom furniture can be primped with paint and dressed in new silks, braids, and fancy finery. Your budget will be happy.

Going junking for bedroom furniture and antique bed linens is one of the great cheap thrills. It's a rewarding way of finding unusual bedroom accessories with odd hardware and old-fashioned craftsmanship, and pillowcases with someone else's monogram. A dusty old dresser rescued from a mangled heap in a cheerful charity junk shop might turn out to be hand-carved but costs as little as $55 or $100.

Striking gold in a thrift store may still require repainting that avocado-green frame, or replacing an orange Lurex seat with something chic-er. But the double-digit prices are seductive — and there are headboards, trunks, tables, chairs, and footstools that are unexpected and individual.

Treasure-hunting at an open-air antique fair or flea market rather than buying at a discount store means finding one-of-a-kind pieces and no-longer-available furniture that will look even smarter over time. An old mirror with funny proportions will always have much more personality than shiny new things.

Saving dollars is not the only virtue of junking. A garage-sale chair with a few signs of wear to the caning or the damask seat can be enjoyed without worrying about nicking the paint. Poking through neighborhood antique shops means rejecting generic design. Old cast-offs make a virtue of quirky character.

Garage sale dressers go for a song, but it's still important to make an informed purchase. The $15 "bargain" chest that has to be repaired will have style, but labor and materials cost extra. To recover the seat of a chair may cost $100 or more for labor, plus perhaps $20 for half a yard of plain cotton, not lavish fab-ric. Spending a lot for upholstery and repairs makes it essential to focus on unique old chairs or sofas with beautiful woodwork or styles that could not be duplicated today.

On an old chair, check that the frame and legs are still holding together and the wood is undam-aged. Try the chair to see that it's comfortable. In-spect the wood to be sure it's not wormy. Turn an up-holstered armchair over to see if the stuffing is in place, the springs are not loose, and the frame is solid. Fabric can be re-placed, but a hardwood frame and springs are essential. Check for rust, mildew, dust, and wood rot. Check drawers and headboards for mildew, water damage, and termites, all traps for unwary sidewalk-sale enthusiasts.

Underpriced (and a bit tatty) pieces with poten-tial can be transformed with imaginative restyling. Home painting can save money. Painted-finished artists may charge from $200 to give an elegant new finish to a nicked antique chair.

ABOVE In her Oakland bedroom, Alice Erb arranges garden roses and irises, inspiration for daybreak, solace at day's end.

OPPOSITE This useful armoire was resurrected with an artful coat of paint. Imaginative reupholstery gave the chair a new life. Design: David Livingston, Mill Valley.

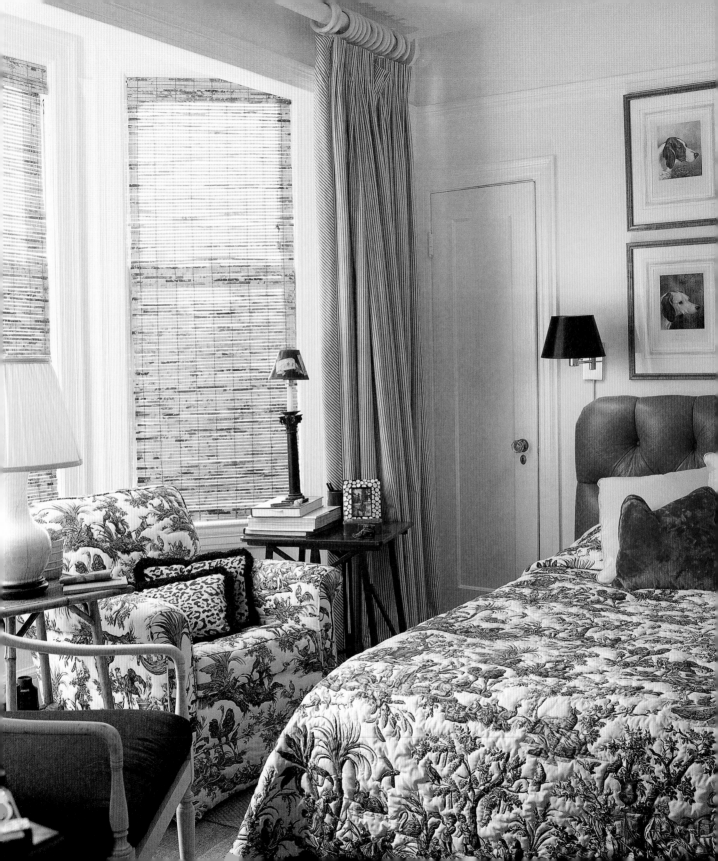

Avid flea marketers have bravado. A table painted a hideous color, covered in dirt, and showing distinct signs of wear can be salvaged. Simply cleaning it off, washing it, and sandpapering will give a good surface for new paint.

How-to books on painted finishes, such as *Paint Recipes* by Liz Wagstaff, are inspirational. The trick is to start with well-made old pieces that don't need complicated paint finishes. Simply painting a table or dresser a plain color may be adequate, but an easy stylized finish — a leaf stencil, a painted border, a gold stripe, or faux bois — will make the finished piece look much more interesting.

Appraise bargain furniture carefully. It may be easy to remove old paint from a traditional iron bed, fix a wobbly leg, or sand off scuff marks. Stripping off varnish, lacquer, or paint to expose beautiful wood underneath may be enough. The result of July jaunts among the junk will be one-of-a-kind furniture that no one else has.

Flea marketeers, remnant-sale junkies, auction hoppers, and seekers of off-beat decorating bargains often overlook beautiful old fabrics, discarded draperies, and vintage textiles. Since much of the decor of a bedroom consists of fabrics — draperies, bedcovers, throws, pillows, slipcovers, headboard covers, bed linens — old textiles can add richness, mood, and design dash to a bedroom.

Among the textiles those in the know desire are fragments of old tapestries, which are faded and perhaps even worn but rich in history and visual pleasure. Pieces of old kilims make graphic and hard-wearing pillows. A few yards of discontinued heavy-weight silk — insufficient to upholster a chair — may be swung into service as a tablecloth or a glamorous headboard slipcover.

TRICKS OF THE TRADE

MEASURE To avoid mistakes, take along measurements of chairs, tables, picture frames, and lamps you need. It's difficult to judge proportions of a bed, a bookshelf, or a lamp on the sidewalk. It's disappointing to get a slipper chair home and find it's too big for the room, or to discover that a dresser won't fit through the door.

RESEARCH Some flea markets are definitely better than others. Cruising through several and comparing notes with friends will find one that's right for your style, pocketbook, and taste.

EARLY BIRD Get there with the dealers, at the crack of dawn, for the best selections. Some enthusiasts state that after 9 AM is too late, that antiques dealers will have raided the best furniture. Getting to know the true collectors helps.

SHOW UP LATE If you can't get there early, some experienced bargain hunters insist that if you go late, just before closing, you can often negotiate prices for what's still left.

POLITENESS To get a great price, be friendly rather than aggressive or too eager.

PLAN Seek and you shall find. Know exactly what you want – but be open-minded. Have a plan so that you're not just searching aimlessly. Know the titles of old decorating books you need. Take swatches of fabrics and paint chips for color reference.

INSPECT Skepticism has its place. Buying at a thrift store or charity store is not like buying at a furniture store. It's as-is. There's no exchange, generally, and it's not possible to return a "treasure" if it doesn't fit, breaks, or turns out to be a reproduction. Old bed linens may have rust spots or mildew that's hard to remove. Inspect carefully.

ACT Sometimes it takes weeks to find the prize. If you're lucky enough to find a well-made piece, and it's love, the right price, and it fits the plan and measurements exactly, buy it on the spot; it won't be there a week later.

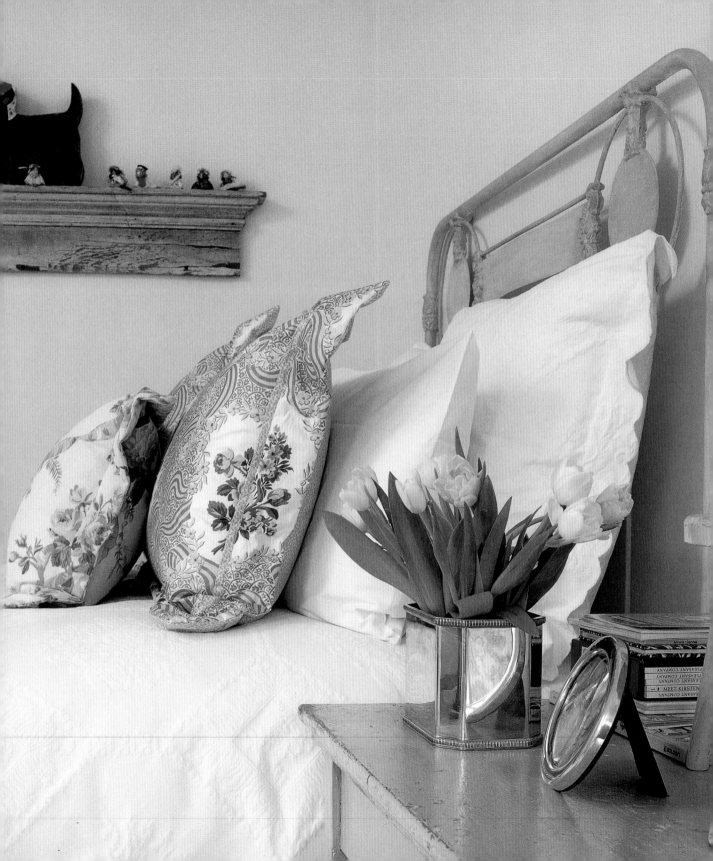

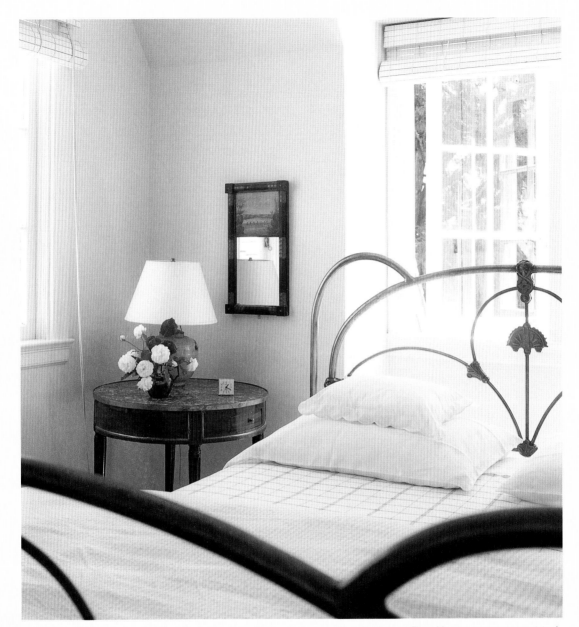

OPPOSITE Antique bedsteads with quirky proportions add great charm to this bedroom. Old wood molding serves as a useful and money-saving wall shelf. Antique and vintage textiles add to the timeless mood. Design: Sudie Woodson.

ABOVE Berkeley designer Elinor Moscow is a master at minimalism. An antique iron bedstead offers graphic grace notes in an all-white room. Note the unobtrusive roll-up wooden shades.

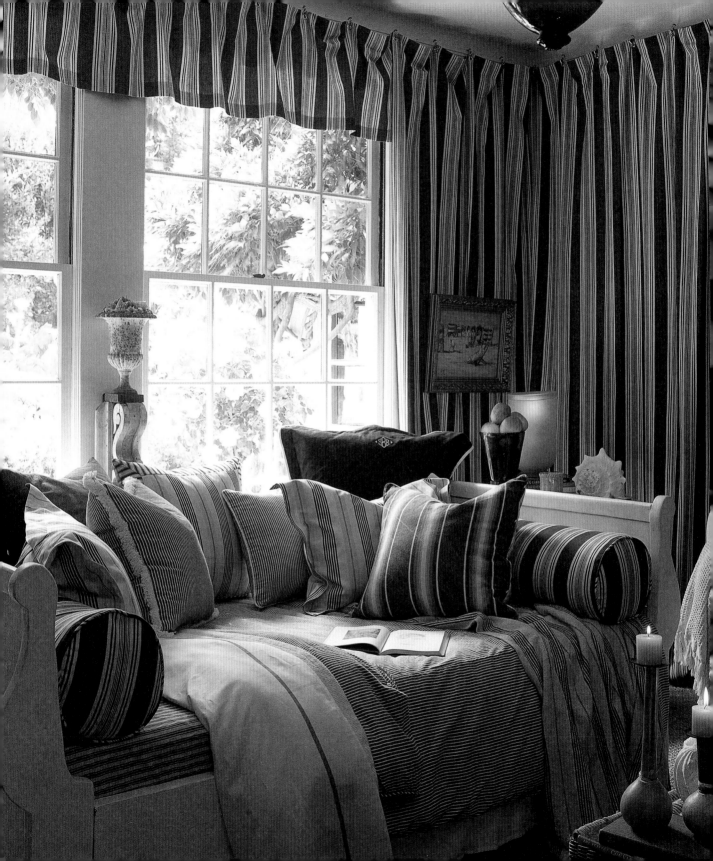

THE GRACIOUS GUEST ROOM

Friends for a weekend, or family for a week? They should be comfortable and very much at ease.

Stinson Beach interior designer Stephen Brady is a gracious, thoughtful host. Weekend guests at his house sleep in superbly detailed rooms with beautiful fresh sheets and towels, extra blankets, hillocks of pillows, generous closets, books to read, and drawings to delight the eye. They're also especially well-fed, with bounty from the region's farmers' markets, neighborhood bakeries, and restaurants. It's a wonder they ever leave.

"I believe in creating a sense of comfort, a sense of being at home," said Brady. He suggested making the guest room inviting and personal, with candles, a stack of the latest magazines, special books, fresh flowers. It does not have to be lavish.

"It's always best if you have a room just for guests, then they don't feel as if they're imposing on you or the family," Brady said. "But even if you live in a small city apartment, or the guest room doubles as a study, you can turn on the charm and comfort."

Brady, a former consultant to the Banana Republic division of Gap, Inc., believes that guest rooms should not look too fussy or elaborate.

"The room should feel uncluttered, neat, and fresh," he suggested, "Open the windows so that the room is airy and not stuffy. Rather than springing for acres of carpet, cover the hardwood floor with a newly washed cotton rug, with linen-bound sisal, or with an old Oriental rug."

The designer attends to important details — and to the subtleties. He often travels to style centers such as Paris, Nice, Florence, Miami, and Los Angeles, and spends time in hotels. He learns from each hotel room just what makes a guest feel at home and what is necessary to make a tired traveler rest and relax.

"I am sensitive to light, so I recommend that you check a guest room window coverings to be sure they are effective," said Brady. "Test shutters, shades, draperies, and blinds to be sure they work and assure a guest's privacy. Be sure that the room may be darkened for sleep during the day. Jet-lagged guests will recuperate best if the room is in complete darkness and is beautifully silent."

And never forget flowers — from the garden, from the flower market, or from a favorite florist. A cluster of roses in a silver julep cup or crystal vase beside the bed shows your attention to detail, and your affection for your guests.

Brady, like other designers, recommends that you sleep in the guest room a night or two to test it for comfort and charm. Are there enough pillows? Is the lighting adequate? Would a swiveling wall-mounted lamp make reading easier? Perhaps a bookcase could be added for magazines, art books, notepads and pencils — all for the delight of your guest.

OPPOSITE & ABOVE Stephen Brady's guest room is an island of comfort and fantasy. Striped ticking, attached on wall hooks, makes the room feel like a tent. The pillow-decked daybed has a handcrafted mattress.

BED The most versatile and useful bed for a guest room is one that converts to a day-bed. It stands against the wall, has a good mattress, and may have an upholstered head and foot. It might, in fact, be an antique iron daybed. Stacking pillows against the wall will make it comfortable for relaxing during the day. Add simple nurturing touches, such as cotton or cashmere throws or a bolster. At night, remove the covers and extra pillows, and turn down the sheets. Be sure the mattress is firm and comfortable. (This is a much better and more stylish arrangement than most sofa beds, which are often mundane and uncomfortable.)

SEAT Be sure to have at least one upholstered armchair or comfortable occasional chair, especially if the room will be accommodating a couple. In a small room, an upholstered bench or a chest with an upholstered top can be a useful space-saver.

IMPROVISE Guests need a table beside the bed for reading glasses, a carafe of water, a lamp, an alarm clock. Instead of a tiny, tippy bedside table, use a stack of old trunks for an instant (and sturdy) sur-

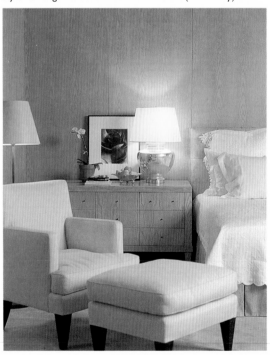

face. The trunks can do double duty as storage for extra pillows and blankets.

TOILETRIES On a small dressing table or dresser, set out colognes, fragrant soaps, shampoo, hand towels. It's considerate to add a sun lotion if you have plans for walking on the beach, hiking, cycling, or sightseeing in a convertible.

MIRRORS Have at least two mirrors with good lighting. One wall-mounted mirror with a decorative frame, or one hand-held mirror (with magnification) will reassure an insecure guest. One full-length mirror inside a closet door or on the front of an armoire door will be useful for both men and women (especially if they're in town for a wedding or another special occasion that requires more formal attire).

LIGHTING Check that lighting is flattering, not harsh. Banish overhead lighting in favor of table lamps, wall-mounted swing-arm lamps, an adjustable bedside lamp, candles, sconces, and perhaps one floor lamp.

VIEW If the guest room has a view, place the bed so that the guest can see the garden or landscape while relaxing on the bed.

PLEASE THE EYE Paintings, sculptures, prints, black-and-white photography, and well-edited collections give the room personality. Brady likes wall collages of vintage photography, old oil paintings, prints.

NO TV Stephen Brady does not believe that televisions belong in bedrooms. "The guest room is a place of repose, of reflection, of rest," Brady said. "It's nice to escape the news, commercials, the noise of the world, and be alone with your thoughts."

STORAGE Guests always need to unpack and hang clothes to remove wrinkles. Provide an old coat rack, an armoire with lots of room, perhaps hooks on the backs of doors, and lots of hangers. Offer a luggage rack so that suitcases can be kept conveniently off the floor.

WINDOWS Test shades, shutters, draperies, and blinds to be sure that the room can be darkened for sleep, especially on the east side of the house. Guests will sleep best if the room is in darkness.

LEFT An armchair with an ottoman spells heaven for a jet-lagged guest.

OPPOSITE An opulent velvet-covered daybed. Designers: Scott Waterman and Brett Landenburger.

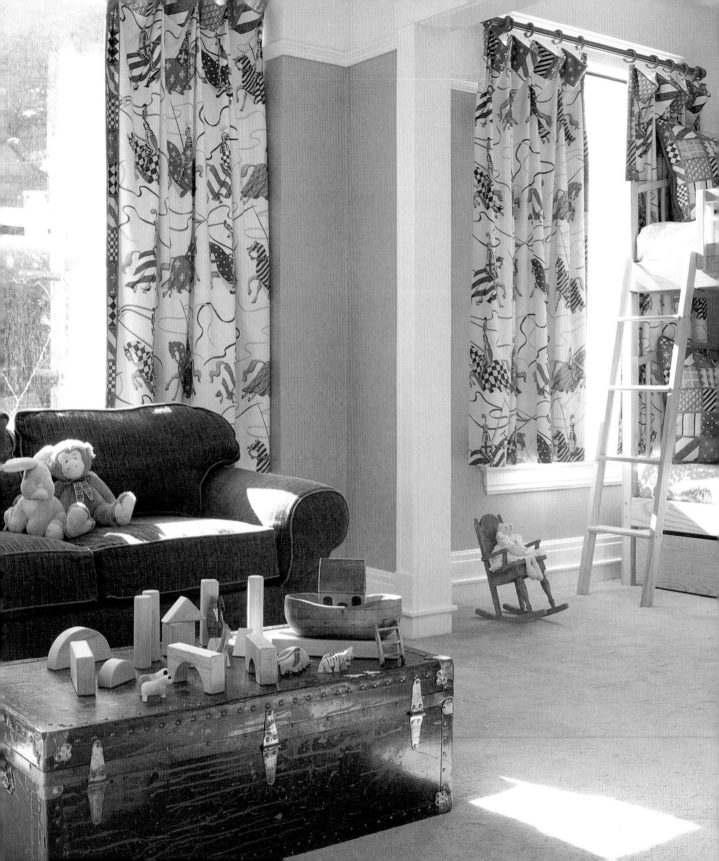

CHILDREN'S BEDROOMS

Children's rooms don't have to be fancy. Make them simple, safe, cozy, and cheerful, and kids will love being there.

A child's room can be a magical realm. Building make-believe caves from blankets and pillows, curling up with a book on a sunny window seat, and playing on the floor for hours with friends are some of the happiest memories of childhood. (Of course, there can be monsters mumbling under the bed and dragons scratching at the windows…but that's another bedtime story.)

It's the feeling of security and comfort that really counts. It's surprising, then, that parents faced with decorating a child's room focus obsessively on aesthetics — agonizing over new furniture design, paint colors, and the latest sheet patterns. New parents, overwhelmed, have been brainwashed into thinking they need specialized products to do battle with every aspect of their baby's life. Actually, it's the parents who want all the stuff — babies sleep a lot and require very little.

Start out simple when furnishing for a newborn. Baby stores are crammed with temptations, and infants' rooms can become full of what is known as "kiddy litter" — neon, plastic, cartoony toys, tiny tables and chairs, and playthings plastered with "cute" and trendy imagery. Most of this will be discarded before the child reaches the age of two. Look instead for classic shapes and timeless concepts.

What really nourish and inspire children are not passing fads, but classic, simple, well-made tactile toys, brain-challenging games, evocative pictures, beautiful books, inspiring art supplies, and lots of outdoor activities with friends and family.

Expectant parents faced with an empty room and worried about filling it should feel no qualms about leaving the room relatively bare for their beloved newborn. A warm, secure crib; a rocking chair for parents, grandparents, and babysitters; a dresser with a good light on top; storage; and lots of fresh air will do nicely. Posters and mobiles are great, too.

Best first buys are maple or white-painted dressers with drawers large enough to hold baby clothes — and eventually, a teenager's sweaters.

A growing toddler needs a comfortable, quiet place to sleep, some stimulating colored objects to look at and play with, and a loving, warm, attentive family. Rocking horses, doll houses, toy carousels, and music boxes are things that memories are made of — but they can wait.

For older children, the essentials are a comfortable nest-like bed, a well-defined and safe play area, privacy, quiet times, and things to stimulate curiosity, learning, and adventure. Kids will spend many a happy afternoon with time to dream, paint, write, or even create a Web page.

When the child starts school (or before), a desk and a computer become essential, along with plenty of wall shelves in plain wood. Clean-lined, basic

ABOVE Sweetly romantic – every girl's dream.

OPPOSITE Bunks, space, sun and sofa. Design: Allison Holder.

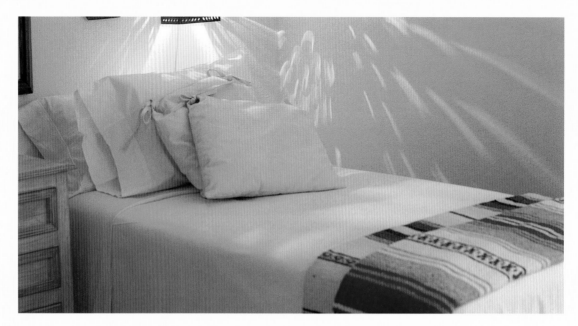

designs are best: They won't look too young after ten years' use. And simplicity, plenty of storage, and open shelves make rooms easier to keep clean.

Children's rooms need a comfortable chair, an old sofa, or a window seat where the enthusiastic reader can curl up for hours, especially in winter. An old club chair can be slipcovered with washable denim for children's rooms. If space is tight, four or five big supportive feather-and-down pillows can be piled against the wall, like a daybed, and offer reassuring back support. A down comforter is ultra-light and provides the cozy, snug warmth children love.

As children's paintings and craft projects make their way home, they can be framed and showcased. With trophies and award ribbons and special recognitions, these are the child's moments of triumph. Memories are indeed made here.

As children grow, storage and neatness become an acute concern — for the parents. Growing young-sters naturally accumulate sporting equipment, specialized footwear, and sports uniforms, plus piles of schoolbooks, backpacks, games, winter coats, collections of action figures and trophies, not to mention cigar boxes full of baseball cards and stamps. Every day, it seems, roller blades, knee pads, elbow pads, wrist pads, and bike helmets lie about. Computer equipment takes up space.

Rather than wrangle with children (generally fruitlessly) about keeping the room tidy, it is most constructive to provide acres of neat storage. Wall shelves, flea-market armoires, home-built desks, hand-me-down dressers, and garage-assembled cabinets will all help solve the clutter crisis. Chests for winter stuff can slide under the bed. An old travel trunk placed at the end of the bed can hold toys — and offer seating for visiting chums.

Find a well-made desk light, an easy chair, ample storage, and a snuggly bed, and you've got a good beginning.

FURNITURE Keep children's furniture friendly and familiar. It doesn't have to be new. A generously proportioned second-hand dresser with a fresh coat of nontoxic paint will be perfectly adequate. A grown-up cousin's favorite bed or a hand-me-down desk and chair will feel more alluring than a shiny new one. (Old cribs, however, are often not safe, and therefore not recommended. Check guidelines for crib safety regulations.)

FORGO A "LOOK" Reject theme design. Sheets, a head-board, curtains, or a rug plastered with gaudy commercial motifs of this year's favorite animal, super-hero, or doll will soon look very dated. Similarly, the pale pastels that for many bespeak babyhood are outgrown when it's time for preschool. Look for fabrics and surfaces that are plain, bright, simple, and adaptable. Colors like periwinkle, rich cream, sunny yellow, and mid-blue freshened with white paint will take a child happily through teenage-hood.

TERRITORIES When two children are sharing a bedroom, work out a way to give each child their own territory. Each should have a separate dresser, shelves, and storage places. Dressers and wall-mounted shelves can be used to display trophies, beach shells, craft projects, and family photographs.

HOMEWORK A neat, well-organized desk, a quiet room, and a comfortable chair help a child focus on study, reading assignments, projects, and homework. Plan wall shelves, floor bins, and perhaps a small file cabinet for keeping track of computer software and disks, school projects, magazines, and pens and pencils.

STORAGE Encourage children to keep orderly rooms by planning adequate pegs, hooks, hangers, shelves, and storage – and extra space for all the new things that seem to accumulate as children grow. Roomy closets and large trunks will rein in sports equipment, athletic footwear, musical instruments, and winter coats and jackets. And if you need more storage space, catalogues (such as Hold Everything) sell roll-away boxes for underbed storage. These are ideal places to keep extra blankets, games, and toys.

RIGHT LIGHT Task lighting is important. A flexible desk lamp and an adjustable wall-mounted bedside reading light is essential. Another improvement: Put lights on dimmers so that they can be fine-tuned from bright to subdued.

BIG BED When a child is old enough to sleep in a bed, buy a twin-size bed and invest in the best mattress you can afford and a sturdy head-board. A down comforter, a fleece blanket, a wool plaid throw, and cushy mattress pads are nice if they fit your budget. This is the warm and inviting "nest" your child will snuggle in for bedtime stories when they're five, collapse on after a soccer game when they're ten, and hide from the world in when they're four-teen. And if you turn the mattress every few months and take care of it, this is the great bed they'll pass on happily to their children.

OPPOSITE Childrens' rooms do not need to be fancy, but they should feel pulled-together, tidy, organized, and secure. A favorite blanket on a bed, cozy sheets – what could be more reassuring?

BELOW Kids love the coziness of old beds. Here, toys are organized to encourage order. Mid-range colors grow with the child.

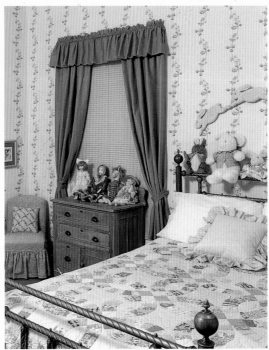

OPPOSITE It's hard to believe that Laura Dunsford's captivating bedroom-sitting room is in a former tractor barn. It's in the wine country north of the Napa Valley, and the bedroom opens directly onto a sunny terrace. White canvas is inexpensive, effective.

ABOVE Architecture and light: It's evident that a beautifully proportioned room with sunlight raking the walls can inspire daydreams. Objects here are humble and utilitarian, and thus have sculptural power.

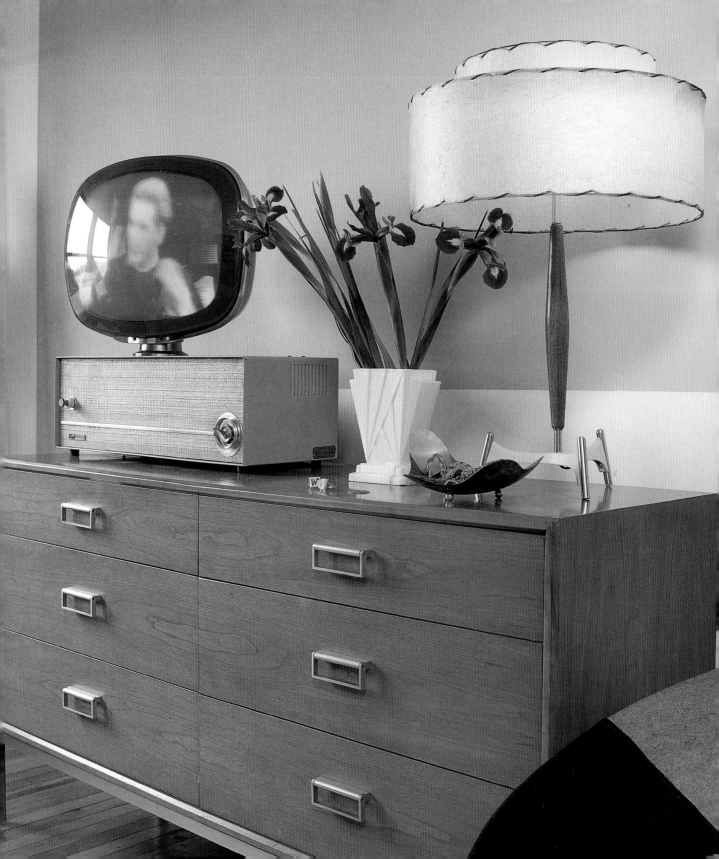

ACCESSORIES

Grace notes of a bedroom: beautiful objects and flowers
help to compose a harmonious mood.

Light a simple, unscented handmade beeswax candle in an elegant gold-dipped candlestick. Draw up a white-linen slipcovered Louis-the-something chair or a dove-gray Gustavian chair to a cool new steel writing desk, and breathe a sigh of relief. There's a liberating, new, please-yourself attitude in home accessories. The tyranny of the status object is over.

Accessories celebrate ingenuity, clearly-expressed individuality, quiet beauty, and sometimes a street-smart style. A wire basket full of pearly shells or a stack of old gardening books can stand on an heirloom bedside table. A vintage chrome desk lamp can be poised beside a terra cotta pot of narcissus on a cheerful chrome-yellow-painted Welsh dresser. Offhand urban style can coexist with rustic elegance.

Old so-called guidelines of decorating don't apply, so there's no cause for fretting anxiously about getting it "wrong." The design police will not visit. Authentic period style is out the window. Modern taste has moved in with Arts & Crafts. Biedermeier shimmies with Anglo-Irish artifacts. The great eras of exploration offer up great panoramas of possibilities for decor. The world is there for inspiration. Anglo-Chinese and old Raj-y Colonial furniture have a certain affinity with early Japanese furniture — even Mexican Colonial. And what could be prettier than a Louis XVI-style chair and a Gustav III chair (repro or real) doing a pretty pirouette with a sturdy Scottish pine chair with a natural linen cushion? A dresser from an estate sale (all very imposing and proper) makes a fine companion for a beaded lamp from Pottery Barn or a vivid piece of art glass from Gump's.

Throughout the year, nature offers up bounty for the finding. One dried maple leaf or a fallen sycamore still golden from the autumn sun would look as exquisite as a fine hinoki-wood carving laid on top of a first edition of Colette's poems. Osage oranges or eucalyptus branches, garden callas, fennel heads, roadside reeds and nasturtiums, arranged simply, are fragrant and secretly thrilling.

Juxtaposition is always intriguing and instructive. But a dresser top composed with only celadon or white objects — a plaster lamp, old porcelain bowls, two or three blanc-de-chine vases, sun-bleached scallop shells, and pink 'Cecile Brunner' roses in a Baccarat urn vase — would be quite uplifting.

"Bedrooms today can be decorated in inexpensive white pique, plain muslin, Irish linen, cotton canvas, even plain natural cotton," said San Francisco designer Stephen Brady. "Accessories don't have to display over-the-top luxury. Mixing accessories — introducing a vividly colored Hermès cashmere throw to pure white cotton sheets — can give the bedroom a sense of vitality."

ABOVE Designer Arnelle Kase's collection of French Ivorine (faux ivory) is especially beautiful clustered beneath a bay window.

OPPOSITE Who would not be won over by the quirky, cartoony charms of these vintage accessories? Design: Mark Marcinik.

Product designer Liz Ross found a funky rusted iron bedframe at Zonal in San Francisco and is waiting to find just the right place for it.

"Quirky objects like old beaten-up gold frames or vases of recycled glass that have personality and age bring more to a room than things that are merely expensive," stylist Jody Thompson-Kennedy of Sausalito says. "They may be harder to find, but they fill rooms with character, with a feeling that someone interesting lives there."

With her pick of the best local designers and stores have to offer, Kennedy's eye is drawn to one-of-a-kind crafts and pieces that are less than "perfect."

"Slickness and insincerity in decor and accessories look all wrong today," said Kennedy. "Choose only things you love, things that will have lasting power. They should be pieces you discover, things you cherish, not just a meaningless display."

Kennedy shops all over Northern California in antique shops and furniture stores and nurseries for garden ornaments, old fabrics, antique lamps, unusual baskets, and heirloom roses. She avoids clutter by putting some things in storage.

"Accessories are a great way to add color to a bedroom without making a big commitment," Kennedy said.

Stylist Sara Slavin also favors an inviting, relaxed, low-key mood rather than ostentatious display.

OPPOSITE Accessories need not be rich or glossy: Michael Duté revels in old trunks, a vintage vase, well-read books.

BELOW Elinor Moscow's bedroom: One simple chair can be all you need as counterpoint to the swooping curves of the bed.

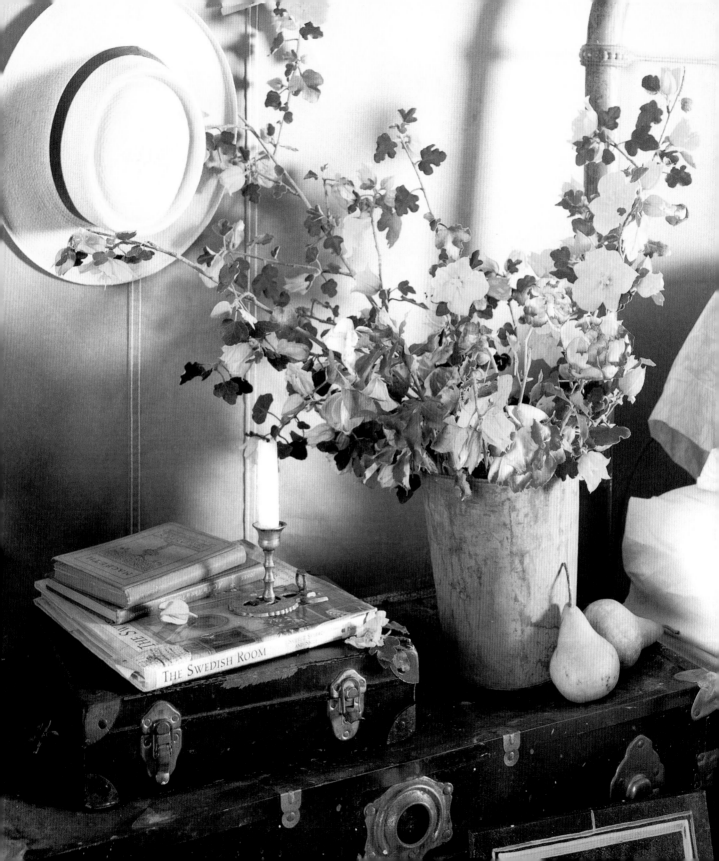

Year-round sunshine in California keeps spirits high and creativity and the passion to buy on the boil. From Mendocino to Big Sur and San Francisco, from St. Helena to Santa Barbara, and from Los Angeles to all points north and south, architects, imaginative designers, impatient artists, and attentive store founders explore fresh possibilities. Working in traditional crafts and with new technologies, designers dream up plates and vases from raw clay, sinuous seats and tables from raw metal, and hypnotic glass bowls and wrought-iron beds with little more than focus, hot air, skill, and optimism. For this updated listing, I have selected singular stores, design galleries and showrooms, and salvage yards. Most have originated from the passion and vision of one highly opinionated founder and knowledgeable owners. These stores and galleries capture the spirit and inspire return visits. Note a new listing of the finest national catalogues for bed linens, down comforters, and other bedroom essentials.

Diane Dorrans Saeks

DESIGN & STYLE STORES

LOS ANGELES

Action Streets: It helps to take along a friend or to be a fearless, observant, and adventurous driver with a good map when design shopping in Los Angeles.

Neighborhoods and lively streets of fresh and intriguing or retro-traditional style include North Robertson Avenue, Melrose Avenue (the western and eastern ends and highlights in between), Melrose Place (the real one), Beverly Boulevard, La Brea Avenue, tidy Larchmont Avenue, parts of

Silver Lake, and out in Santa Monica. The fun part is shopping for old lighting, salvaged bathroom fixtures, garden antiques (to bring indoors), cachepots, funky movie-set French furniture (which may have been sat on by Cary Grant or Fred Astaire), monogrammed linen sheets, vintage fabrics, steel hospital furniture, and patio chairs. Screeching to a halt in front of a just-opened store in a funny part of town is bliss!

**AMERICAN RAG CIE
MAISON ET CAFE
148 S. La Brea Avenue
(Also in San Francisco)**
Cheerful handcrafted glasses, hand-painted plates, cozy custom upholstery. California/French style with Provençal pottery, books, and accessories for every room – plus a tiny cafe.

**ANICHINI
466 N. Robertson Boulevard**
Luxe. Bedroom glamour. Gorgeous silk-bound cashmere blankets, linen sheets, jacquard weave throws, and heirloom blankets.

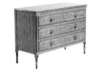

**BRENDA ANTIN
7319 Beverly Boulevard**
Antique French and English garden decor outside catches the eye, but once inside this magical place, the senses are thrilled by English quilts, monogrammed white-linen slipcovers and lamp shades, French quilts, vintage French textiles, and great, unusual colors everywhere.

**BLACKMAN-CRUZ
800 N. La Cienega Boulevard**
Fast turnover, so you have to keep coming back. Sculptural and often quite odd twentieth-century objects and furniture. Architectural fragments. A favorite with architects and Hollywood set designers.

**BOOK SOUP
8818 Sunset Boulevard
West Hollywood**
Must-visit bookstore, with all-day and midnight browsing. Superb selections of design, architecture, and photography books. Open-air magazine stand has every international design magazine. Bistro.

**CITY ANTIQUES
8444 Melrose Avenue**
A great source for eighteenth-through twentieth-century furniture, some by admired but slightly obscure designers. An eclectic, influential look.

**NANCY CORZINE
8747 Melrose Avenue**
To the trade only. Elegant, suave, sexy updated classic furnishings. Outstanding Italian fabric collection.

DIALOGICA
8304 Melrose Avenue
Smooth contemporary/thirties-influenced furniture.

DIAMOND FOAM & FABRIC
611 S. La Brea Avenue
Jason Asch's empire expands along La Brea. Style insiders' favorite for instant fabric gratifications, excellent prices. Now a not-so-secret trade source for basic and decorative this-minute fabrics. Easy to find here are simple and luxurious textiles — velvets, linen, chintz, silk, damask, twills, challis, terry, all in just the right colors. (Pop in to La Brea Bakery, opposite, for superb sour cherry and chocolate chip bread loaves.)

DIVA
Corner of Beverly Boulevard and N. Robertson Drive
In the heart of the to-the-trade design center. Offers all the contemporary design icons — like Philippe Starck — that could be on every corner in Los Angeles and are rare. (Designers in Southern California prefer the past.)

RANDY FRANKS
8448 Melrose Place
One-of-a-kind furniture. New designers.

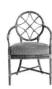

HOLLYHOCK
214 N. Larchmont Boulevard
A cheerful, elegant look. Furniture, mirrors, and decorative accessories for rooms and gardens.

INDIGO SEAS
123 N. Robertson Boulevard
Gin Fizz anyone? Lynn von Kersting's style: part Caribbean Colonial outpost, part Riviera, part romanticized England. Witty. Sofas, silver, soaps.

LIEF
8922 Beverly Boulevard
Elegant pared-down Gustavian antiques and simple Scandinavian Biedermeier are a refreshing change from Fine French Furniture.

LA MAISON DU BAL
705 N. Harper Avenue
Antique and vintage textiles, lighting.

MODERNICA
7366 Beverly Boulevard
Modernist furniture, focusing on twenties to sixties.

RICHARD MULLIGAN–SUNSET COTTAGE
8157 Sunset Boulevard
To the trade only: 213-650-8660. Great. Entrancing. With your decorator in tow, get seduced by Mulligan's completely chic and sophisticated country vision. Richard and Mollie have star power — and a devoted following among old-timers, Hollywood designers, and celebs. Antique and vintage country-style antiques. Finely finessed painted reproductions and collectible paintings, pottery, one-of-a-kind lamps.

ODALISQUE
7278 Beverly Boulevard
Linger among the funky antiques, vintage silks, chandeliers, and pillows. Surprising and quirky. Antique fabrics. One-of-a-kind pillows and draperies made from embroidered ecclesiastical fabrics.

PACIFIC DESIGN CENTER
8687 Melrose Avenue
To-the-trade showrooms such as Mimi London, Donghia, Randolph & Hein, Snaidero, McGuire, Brunschwig & Fils, Baker, Oakmont, and Kneedler-Fauchere present the finest fabrics, furniture, lighting, rugs, hardware, reproductions, decorative accessories, fixtures. Very professional, totally top-of-the-line.

RIZZOLI BOOKSTORE
9501 Wilshire Boulevard (Also in Santa Monica)
Outstanding selection of design and architecture books. Browse among the stacks. Open late.

ROOMS
619 N. Croft Avenue
By appointment: 213-655-9813. Interior designer Michael Berman's studio with his custom-made furniture.

ROSE TARLOW–MELROSE HOUSE
8454 Melrose Place
Rose Tarlow, designer and lecturer, has a fine-tuned sense of scale, along with a dash of humor. Her furniture collection demonstrates an understanding of comfort, elegance, line, and grace. A certain Continental/English sensibility, languor, and timeless glamour.

RUSSELL SIMPSON COMPANY
8109 Melrose Avenue
Bret Witke and Diane Rosenstein sell furniture from the forties and fifties. Eames, Jacobsen, Saarinen, Robsjohn-Gibbings, et al.

VIRTUE
149 S. La Brea Avenue
Andrew Virtue's fresh and totally chic antiques and decoration shop. Madeleine Castaing and Elsie de Wolfe live on! Colorful, witty, and joyful. Garden furniture you can bring indoors, paintings, pillows.

W ANTIQUES AND ECCENTRICITIES
8925 Melrose Avenue
Melissa Wallace Deitz's domain — an effervescent gallery selling everything from eighteenth-century gilded chairs to bird-cage-shaped chandeliers, fountains, urns, art deco furniture. It's one of a kind and ever changing.

SAN FRANCISCO

My definitive list of the best design and style stores includes all my favorite shopping streets: Fillmore, Hayes, Brady (off Market), Post, Sutter, Sacramento, Gough, Geary, Union Square and Street, the northern end of Polk. For top-notch stores, explore Fillmore Street — from Pacific Avenue to Bush Street. Then march along Sacramento Street. And don't forget South Park, South of Market, and the Mission District.

AD/50
711 Sansome Street
New downtown location for modernist and contemporary furniture (including designs by Park Furniture and Christopher Deam).

AGRARIA
1051 Howard Street
A fragrant favorite. Maurice Gibson and Stanford Stevenson's classic candles, potpourri, and soaps are tops. (Best selection is at Gump's.)

ARCH
407 Jackson Street
Architect Susan Colliver's colorful shop sells supplies for designers, architects, and artists — and home improvement fanatics. Excellent range of papers.

BANANA REPUBLIC
256 Grant Avenue
Sparkling new flagship store includes a refined home department. Well-priced dinnerware, crystal, frames, silk pillows, linens.

BELL'OCCHIO
8 Brady Street
Claudia Schwartz and Toby Hanson's whimsical boutique offers soaps, hand-painted ribbons, French silk flowers. Trips to Paris produce charming antiques, hats, posters, and retro-chic Parisian face powders.

GORDON BENNETT
2102 Union Street
Fresh garden style throughout the seasons. Vases, plants, books, candles, decoupage plates, and tools. Ask the owner to explain the name — and to introduce his standard poodles.

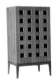

BLOOMERS
2975 Washington Street
Top people speed-dial Patric Powell's fragrant domain. Bloomers offers the freshest cut flowers (totally tasteful) and unusual orchids in terra cotta pots. Dozens of vases, French ribbons, and baskets. Nothing overdone or tricked-up here — just nature's natural beauty.

VIRGINIA BREIER
3091 Sacramento Street
A gallery for contemporary and traditional American crafts.

BRITEX
146 Geary Street
Excellent for home sewers. Growing home design sections. Action central for thousands of fabrics. World-class selections of classic and unusual furnishing textiles, braids, notions.

BROWN DIRT COWBOYS
2418 Polk Street
Painted and refurbished furniture, housewares.

BULGARI
237 Post Street
Browse in the superb upstairs silver department — it's heaven — then bestow something sparkling and elegant upon yourself.

CANDELIER
60 Maiden Lane
Wade Benson's beautifully styled candles, books, vases, and home accoutrements. Candlesticks and tabletop decor.

THOMAS E. CARA
517 Pacific Avenue
Espresso machines and hardware — a long-time company, very authoritative.

CARTIER
231 Post Street
Elegant selection of accessories, silver, crystal, vases, porcelain.

COLUMBINE DESIGN
1541 Grant Avenue
In North Beach, Kathleen Dooley displays fresh flowers, gifts, along with shells, graphic framed butterflies, bugs, and beetles.

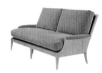

THE COTTAGE TABLE COMPANY
550 18th Street.
Tony Cowan's heirloom-quality hardwood tables to order. Shipping available.

DE VERA
580 Sutter Street
Magic shop. A must-visit, one-of-a-kind store. *Objets trouvés*, sculpture, Venetian glass, original small-scale finds, and original designs by Federico de Vera. De Vera recently opened a new store at 29 Maiden Lane, selling small, precious *objets d'art*.

DE VERA GLASS
384 Hayes Street
A vibrant gallery of singular glass objects by contemporary American artists, along with Venetian and Scandinavian classics. Unusual colors.

DECORUM
1400 Vallejo Street
Jack Beeler's art deco domain.
Superb lighting, furniture. Open
Saturdays.

F. DORIAN
388 Hayes Street
Treasures galore – at excellent
prices. Contemporary acces-
sories, folk arts, and antiques.

EARTHSAKE
2076 Chestnut Street
(Also in the Embarcadero
Center in San Francisco, and
in Berkeley and Palo Alto)
Earth-friendly stores with pure
and simple furniture, untreated
bed linens and towels, vases
made of recycled glass, candles.

FILLAMENTO
2185 Fillmore Street
Trend alert! For more than a
dozen years, a museum for
design aficionados. Owner Iris
Fuller stacks three floors with
style-conscious furniture, table-
ware, towels, mirrors, glass,
toiletries, and gifts. Iris is first
with new designers and sup-
ports local talent, including
Nik Weinstein, Willsea O'Brien,
Ann Gish, and Annieglass.
Frames, lamps, linens, beds,
and partyware.

FIORIDELLA
1920 Polk Street
For more than 17 years, this
store has been offering the most
beautiful flowers and plants. Fine
selection of decorative acces-
sories and versatile vases.

FLAX ART AND DESIGN
1699 Market Street
Tempting, exhaustive selections
of frames, paper, lighting, table-
top accessories, boxes, art
books, furnishings. One-stop
shopping for art supplies.
Catalogue.

FORZA
1742 Polk Street
Handcrafted furniture, candles,
accessories with an urbane
elegance. Great aesthetic.

GALLERIA DESIGN CENTER
AND SHOWPLACE DESIGN
CENTER
Henry Adams Street
Come to this South of Market
design center with your decora-
tor or architect. Selections and
temptations are extraordinary.
A professional's eye can lead you
to the right chairs, tables, sofas,
trims, silks, accessories, fabrics.
These to-the-trade-only build-
ings – along with Showplace
West and other nearby show-
rooms – offer top-of-the-line
furniture, fabrics, and furnishings.
Randolph & Hein, Kneedler-
Fauchere, Sloan Miyasato, Shears
& Window, Clarence House,
Jack Lenor Larsen, Palacek,
Brunschwig & Fils, Schumacher,

Therien Studio, McRae Hinckley,
Donghia, Summit Furniture, Enid
Ford, and Houlès are personal
favorites. (Purchases may also be
made through a buying service.)
Explore the neighborhood and
find Therien & Co (Scandinavian,
Continental, and English
antiques), Robert Hering anti-
ques, and the handsome, almost-
residential Palladian outpost of
Ed Hardy San Francisco (eclectic
antiques, garden antiques, and
worldly reproductions).

STANLEE R. GATTI FLOWERS
Fairmont Hotel, Nob Hill
Fresh flowers, Agraria potpourri,
vases, and candles.

GEORGE
2411 California Street
Style for dogs and cats, including
dog beds, Todd Oldham- and
Tom Bonauro-designed charms,
toys, cedar pillows, bowls and
accessories. Best dog treats:
handmade whole-grain biscuits.

GREEN WORLD MERCANTILE
2340 Polk Street
Earth-friendly housewares,
clothing, gardening equipment,
books, and unpretentious deco-
rative accessories. Plants and
gardening equipment.

GUMP'S
135 Post Street
Visionary Geraldine Stutz and
her snappy team dreamed up
this new, chic Gump's – with
superbly selected fine crafts,
art, Orient-inspired accessories,
plus tip-top names in silver, crys-
tal. Cushy and very elegant bed
linens. An essential stop. Be sure
to visit the Treillage garden an-
tiques shop, and the decorative
glass departments. Catalogue.

GYPSY HONEYMOON
Corner of 24th and
Guerrero streets
Magical and romantic decor.
Art glass, refurbished furniture,
beds, old mirrors, trunks, framed
vintage prints.

HERMES
212 Stockton Street
Silk scarves here are the ulti-
mate, but climb the limestone
stairs to find tableware, blankets,
cashmere throws, picnicware,
silver, chic decor.

RICHARD HILKERT BOOKS
333 Hayes Street
Like a gentleman's library. Designers and book addicts telephone Richard to order out-of-print style books and newest design books. Browse here, buy, then stroll to the Opera or the Symphony.

IN MY DREAMS
1300 Pacific Avenue
Jewelry designer Harry Fireside's dreamy shop for soaps, antiques, and Chinese lanterns.

JAPONESQUE
824 Montgomery Street
Passionate Koichi Hara demonstrates his lifelong devotion to refinement, tradition, harmony, simplicity, and natural materials. Japanese sculpture, glass, furniture. Timeless and tranquil gallery.

FORREST JONES
3274 Sacramento Street
A Pacific Heights favorite. Baskets, housewares, porcelain, excellent lamps.

JUICY NEWS
2453 Fillmore Street
A jumping joint for every possible international fashion, design, architecture, and style magazine – and fresh fruit refreshments.

KRIS KELLY
One Union Square
Selections of beds, fine linens, and table linens.

SUE FISHER KING
3067 Sacramento Street
Sleeping beauties for bed-lovers. Sue King's Italian, French, and English bed linens, cashmere throws, and tableware are the chic-est and prettiest. Luxurious blankets, hand-dyed Himalayan cashmere fringed throws, silk pillows, plus accessories, books, soaps, furniture, and Diptyque candles.

LIMN
290 Townsend Street
The place to be on Saturday afternoons – after the Farmers' Market at Ferry Plaza. One of only a handful of Northern California stores selling top-of-the-line contemporary furniture, accessories, and lighting by more than 300 international manufacturers. Well-priced, to-go collections along with to-order Philippe Starck, B & B Italia, Andree Putman, and Mathieu & Ray, plus top Northern California talent. Ceramics by Cyclamen. Visit the new gallery behind the store.

DAVID LUKE & ASSOCIATE
773 14th Street
Antiques, vintage tableware, funky furniture, old garden ornaments – some of it from the estates of England. (David's boxer, Baby, is his associate.)

MAC
1543 Grant Avenue
Chris Ospital's trend-setting salon sells style inspiration and accessories. Stop and chat: Talent-spotter Chris knows who's new.

MACY'S
Union Square
Large bed linens department – excellent selection of down comforters. Furniture and accessories floors and the Interior Design Department are now in the old Emporium building on Market Street.

MAISON D'ETRE
92 South Park
In a Toby Levy-designed building, changing collections of vintage garden furniture (for indoors), lighting, hand-blown glass bowls by local artists, candlesticks, metal vases, candles. Presented with spirit.

MIKE FURNITURE
Corner of Fillmore and Sacramento streets
Directed by Mike Moore and partner Mike Thakar and their energetic crew, this friendly, sunny store offers updated furniture classics-with-a-twist by Mike Studio, Beverly, and other manufacturers. Custom and bespoke design here is very accessible. One-stop shopping for fast-delivery sofas, blankets, fabrics, lamps, tables, fabrics, accessories.

NAOMI'S ANTIQUES TO GO
1817 Polk Street
American art pottery! Bauer and Fiesta, of course, plus historic studio pottery. American railroad, hotel, luxury liner, Navy, dude ranch, and bus depot china.

NEST
2300 Fillmore Street
In a sunny Victorian building where a friendly pharmacy operated for decades, Marcella Madsen and Judith Gilman have feathered their charming Nest. Seductive treasures include books, silk flowers, antique beds, Shabby Chic sheets, rustic French antiques, Italian prints, sachets, sofa, and Bravura lamp shades and pillows. New: quirky trove from Parisian and Provençal flea markets.

PAINT EFFECTS
2426 Fillmore Street
Paint a bed! Colorful, inspiring. Sheila Rauch and partner Patricia Orlando have a fanatical following for their innovative paints and tools. Hands-on paint technique classes by talented Lesley Ruda, along with everything for French washes, gilding, liming, crackle glazing, decoupage, stenciling, and other fine finishes.

PAXTON GATE
1204 Stevenson Street
Peter Kline and Sean Quigley's gardening store offers uncommon plants (such as sweetly scented Buddha's Hand citron trees), vases, and hand-forged tools.

POLANCO
393 Hayes Street
Superbly presented Mexican fine arts, photography, and crafts. Museum curator Elsa Cameron says you can't find better quality anywhere in Mexico.

POLO RALPH LAUREN
Crocker Galleria, corner of
Post and Kearney streets
Ralph Lauren's handsome emporium purveys the complete Home collection. Great beds. Best-quality furniture, accessories, beds, towels, linens, and the trappings of fine rooms, country houses.

POTTERY BARN
Stores throughout California
This on-a-roll San Francisco–based company has stores all over the country, including New York. New full-service design stores offer furniture, rugs, beds, sheets, draperies, special orders. Practical, well-priced home style. Excellent bedroom basics. Classic, accessible design. Outstanding catalogue.

RAYON VERT
3187 16th Street
Brilliant floral designer Kelly Kornegay's garden of earthly delights just got bigger – and better. Vintage furniture, Oriental porcelains, flowers, artifacts, glasses, architectural fragments in a full-tilt, humble-chic setting.

RH
2506 Sacramento Street
Sunny garden and tableware store has beeswax candles, vases, goblets. Inspiring selection of cachepots, vases. Topiaries, too.

RIZZOLI BOOKS
117 Post Street
Library-like, well-located near the Gap, Polo, Diesel, TSE, Gump's. Book-lovers' paradise. Outstanding collection of design, architecture, and photography books. Cafe.

SAN FRANCISCO MUSEUM
OF MODERN ART
151 Third Street
Outstanding design and art books, modernist accessories, framed posters, handcrafted designs by local artists.

SATIN MOON FABRICS
32 Clement Street
Twenty-six-year-old store sells a well-edited collection of decorating linens, trims, chintzes, and other well-priced fabrics.

SCHEUER LINENS
340 Sutter Street
Fine-quality bed linens, blankets. The staff facilitates custom orders particularly well.

SHABBY CHIC
3075 Sacramento Street
(Also in Los Angeles)
A local favorite. Specializes in fat and slimmed-down chairs and cozy sofas with comfortable airs and loose-fitting slipcovers.

SLIPS
1534 Grant Avenue
Sami Rosenzweig's spirit lives on! Custom-made slipcovers for chairs, headboards, and sofas, plus draperies, ottomans.

SUE FISHER KING HOME AT
WILKES BASHFORD
375 Sutter Street
Luscious luxuries. Sue's obsessive perfectionism is evident in her selections of Ann Gish linens, Venetian and Florentine cashmere throws, beds, hand-blown glass, Venetian pillows, and special *objets d'art* from Italy, France, London. Books.

TAMPOPO
55 Potrero Avenue
Old favorite. Japanese-influenced aesthetic, antiques – very versatile.

TIFFANY & CO
350 Post Street
Lusting for a sapphire ring, or a Paloma Picasso necklace? Then step upstairs to the venerated crystal, china, and silver departments. Order Elsa Peretti's classic glasses, bowls, and silver.

WILLIAMS-SONOMA
150 Post Street
(and around the country)
Everything for cooks and kitchens – or breakfast in bed. Flagship for the Williams-Sonoma cookware empire. Stores throughout the state, including Corte Madera, Palo Alto, Pasadena. Delicacies. Quality, lifetime basics for both serious and dilettante cooks. Excellent catalogues.

WILLIAM STOUT ARCHITECTURAL BOOKS
804 Montgomery Street

The best! Architect Bill Stout's chock-a-block book store specializes in basic and wonderfully obscure twentieth-century architecture publications, along with new and out-of-print interior design and garden books. Catalogues.

WORLDWARE
336 Hayes Street

Friendly chic style and design. Shari Sant's eco-store sells cozy sheets and blankets, and such delights as patchwork pillows, aromatherapy candles. Interiors crafted by Dan Plummer from salvaged materials.

ZINC DETAILS
1905 Fillmore Street

The vibrant store has a cult following. Well-priced contemporary furniture, lighting. Hand-blown glass vases and lamp shades by California artists. Domain of Wendy Nishimura and Vasilios Kiniris. (No, they don't sell anything made of zinc.)

ZONAL HOME INTERIORS
568 Hayes Street

Russell Pritchard's pioneering store presents rustic furniture and decorative objects. He made rust and the friendly textures of loving use fashionable. Old Americana at its most whimsical.

BERKELEY, ELMWOOD

Head over the Bay Bridge. Design store action here is focused on wonderfully revived Fourth Street. We recommend, too, a detour to Cafe Fanny, the Acme Bread bakery, Chez Panisse, and the Elmwood neighborhood.

BERKELEY MILLS
2830 Seventh Street

Handcrafted Japanese- and Mission-influenced furniture. Blends the best of old-world craftsmanship and high-tech methods. Catalogue.

BUILDERS BOOKSOURCE
**1817 Fourth Street
(Also in San Francisco)**

Well-considered design, architecture, gardening, and building books.

CAMPS AND COTTAGES
2109 Virginia Street

Visit the cafe at Chez Panisse or the great Cheese Board, then pop in for a visit. Charming homey furniture and low-key accessories. Adirondack styles.

ELICA'S PAPERS
1801 Fourth Street

Japanese handmade papers. Custom-made stationery, albums, frames, paper wall-hangings, decorative boxes, sketchbooks, some from mulberry bark. Papers can be used for making lamp shades, window shades, screens, even wallpaper.

THE GARDENER
1836 Fourth Street

Pioneer Alta Tingle's brilliant, bustling garden-style store sells vases, books, tables, chairs, paintings, clothing, toiletries, and tools for nature-lovers — whether they have a garden or are just dreaming. Asian antiques, terra cotta pots. Consistently original, classic style.

LIGHTING STUDIO
1808 Fourth Street

Lighting design services. Cheery and chic contemporary lamps.

THE MAGAZINE
1823 Eastshore Highway

Four-year-old store sells contemporary American and European designs. Artemide, Flos, Flexform, Aero, and Cappellini, and many others.

OMEGA TOO
2204 San Pablo Avenue

Gold — from salvaged houses in the area. Building materials, fixtures, lighting, plus treasures. Some aficionados mine this store and sibling Ohmega Salvage at 2407 San Pablo Avenue weekly.

RESTORATION HARDWARE
1733 Fourth Street

(More than 30 stores around the country, including Corte Madera, Santa Monica.) The best of the past. Upholstered furniture, wood furniture in Mission, Arts & Crafts and Shaker styles, lamps, garden equipment, quirky drawer pulls, hardware.

SUR LA TABLE
1806 Fourth Street

Outpost of the 24-year-old Seattle cookware company but feels entirely original to Berkeley. In a 5,000-square-foot "warehouse," the shop stocks every goodie, gadget, tool, utensil, plate, machine, and kitchen decoration for serious and dilettante cooks. Catalogue, too.

TAIL OF THE YAK
2632 Ashby Avenue

Longtime partners Alice Hoffman Erb and Lauren Adams Allard have created a magical mystery store that is always worth a trip — across the Bay or across the Atlantic. Whimsical vases, accessories, wedding gifts, Mexican furniture, fabrics, ribbons, notecards, Lauren's books, linens, and antique jewelry.

ERICA TANOV
1627 San Pablo Avenue

The place for linen pajamas, romantic bed accessories. Erica's lace-edged sheets and shams, and linen duvet covers are quietly luxurious. (Drop in on Kermit Lynch Wine Merchants, Acme Bread, and Cafe Fanny just up the street.)

URBAN ORE
1333 Sixth Street

One city block of salvaged architecture and house throw-aways. Doors, windowframes, shutters, lighting fixtures, furniture, and vintage fixtures. An adventure!

ZIA HOUSEWORKS
1310 Tenth Street
Colin Smith's sun-filled gallery-store offers a vivid variety of hand-crafted furniture designs and art. Mike Furniture Studio and Maine Cottage collections.

BIG SUR

THE PHOENIX
Highway 1
An enduring store where you can linger for hours to the sound of wind chimes. Hand-crafted decorative objects, candles, glass, books, sculpture, woven throws, hand-knit sweaters by Kaffe Fassett (who grew up in Big Sur), and soaps. Coast views from all windows. Be sure to walk downstairs. Crystals and handmade objects on all sides. Visit Nepenthe restaurant up the hill. The sixties spirit lives on in Big Sur. Still gorgeous after all these years.

CARMEL

CARMEL BAY COMPANY
Corner of Ocean and Lincoln
Tableware, books, glassware, furniture, prints.

FRANCESCA VICTORIA
250 Crossroads Boulevard
Decorative accessories for garden and home. Fresh style.

LUCIANO ANTIQUES
San Carlos and Fifth streets
Cosmopolitan antiques. Wander through the vast rooms – to view furniture, lighting, sculpture, and handsome reproductions.

PLACES IN THE SUN
Dolores Avenue, near Ocean Avenue
Decor from sunny climes. Provençal tables, Mexican candlesticks, colorful fabrics.

CARMEL VALLEY

TANCREDI & MORGEN
Valley Hills Shopping Center
Carmel Valley Road
Chic, understated country style. Bed dressing, vintage vases, fabrics, chairs, rustic ornament.

FORT BRAGG

STUDIO Z MENDOCINO
711 North Main Street
Interior designers like Michael Berman and Barbara Barry love Zida Borcich – one of the last letterpress printers. She hand-sets old letterpress ornaments on fine papers and prints on antique presses. Her goldfoil and black logos – flowers, teapots, bees, dragonflies, a chef, a watering can – are chic and smart for modern correspondence and letter writing in bed. (Phone 707-964-2522 for an appointment.)

GLEN ELLEN

THE OLIVE PRESS
Jack London Village
14301 Arnold Drive
Everything pertaining to olives – including hand-blown martini glasses. Extra-virgin olive oils, cooking equipment, tableware, linens.

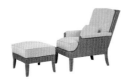

HEALDSBURG

JIMTOWN STORE
6706 State Highway 128
Cycle on country roads to J. Carrie Brown and John Werner's friendly store in the Alexander Valley. The Mercantile & Exchange vintage Americana is cheerful and very well-priced.

SOTOYOME TOBACCO COMPANY
119 Plaza Street
Myra and Wade Hoefer's chic cigar store in a Greek Revival building – originally a Bank of America. The name is that of the original Spanish land grant upon which Healdsburg was founded. Humidors, French silver cutters, cigar posters, and cigars.

MENLO PARK

MILLSTREET
1131 Chestnut Street
Objects of desire: Continental antiques, Ann Gish bed linens and silks, Tuscan pottery, tapestries, orchids, mirrors, botanical prints, silk and cashmere throws.

MENDOCINO

When in Mendocino, be sure to make a dinner reservation at Cafe Beaujolais.

FITTINGS FOR HOME AND GARDEN
45050 Main Street
Furniture, lighting, hardware, accessories. Large selection of garden tools and lamps.

THE GOLDEN GOOSE
45094 Main Street
An enduring favorite. Superb, pristine classic linens, antiques, overlooking the Headlands and the ocean. Baby linens, cashmere and merino throws. The most stylish store in Mendocino.

LARK IN THE MORNING
10460 Kasten Street
Handcrafted musical instruments to display and play. Traditional harps, guitars, violins, as well as ethnic instruments from around the world: ouds, bagpipes, pennywhistles, flutes – and CDs.

STICKS
45085 Albion Street
The utterly charming "twigs and branches" store of Bob Keller. Rustic furniture, decor, and accessories – without the cliches. Great chairs, willow headboards.

WILKESSPORT
10466 Lansing Street
In addition to nifty sportswear, Wilkes Bashford offers David Luke antiques, crafts of the region, and paintings.

MILL VALLEY

CAPRICORN ANTIQUES & COOKWARE
100 Throckmorton Avenue
This quiet, reliable store seems to have been here forever. Basic cookware, along with antique tables, dressers, and cupboards.

PRAIRIE GARDEN
14 Miller Avenue
Garden style for indoors or out. Furniture, plants, great color palette.

PULLMAN & CO
108 Throckmorton Street
Luxurious bed linens, along with furniture, lamps, tableware, and accessories.

SMITH & HAWKEN
35 Corte Madera
The original. Nursery (begun under horticulturist Sarah Hammond's superb direction) and store. Everything for gardens. Also in Pacific Heights, Berkeley, Palo Alto, Los Gatos, Santa Rosa, and points beyond. Catalogue.

SUMMER HOUSE GALLERY
21 Throckmorton Street
Impossible to leave empty-handed. Artist-crafted accessories and (to order) comfortable sofas and chairs. Witty hand-crafted frames, glassware, candlesticks, and colorful accessories. Slipcovered loveseats, vases, tables, gifts.

MONTECITO

BILL CORNFIELD GALLERY
539 San Ysidro Road
Indian, European, European antiques. Very eclectic, charming.

PIERRE LAFOND/ WENDY FOSTER
516 San Ysidro Road
Handsomely displayed household furnishings, books, accessories, and South American and Malabar Coast furniture. Beautiful linens.

WILLIAM LAMAN
1496 E. Valley Road
Country antiques, casual furniture, garden accessories.

OAKLAND

MAISON D'ETRE
5330 College Avenue
Indoor/outdoor style. Eccentric, and whimsical decorative objects and furniture for rooms and gardens.

OAKVILLE

OAKVILLE GROCERY
7856 St. Helena Highway
No visit to the Napa Valley would be complete without a stop here. Extraordinary wine selection, prepared foods, local olive oils, herbs, international cheeses, organic coffees, and locally baked artisan breads. Everything for breakfast in bed, picnics, parties. (Check out Dean & DeLuca in St. Helena, too.)

PALO ALTO

BELL'S BOOKS
536 Emerson Street
Reading-in-bed lovers alert! Walls of fine and scholarly selections of new, vintage, and rare books on every aspect of interior design, gardens, and gardening. Also literature, books on decorative arts, photography, cooking.

HILLARY THATZ
Stanford Shopping Center
Thorough. A dreamy view of the interiors of England, as seen by Cheryl Driver. Traditional accessories, furniture, frames, and decorative objects. Garden furnishings.

POLO-RALPH LAUREN
Stanford Shopping Center
Definitive. Just gets better and better – great versatile decor, linens, blankets. A spacious, gracious store. The expanding world imagined through Ralph Lauren's eyes. Outstanding selection of furniture, imaginary heritage accessories. Catalogue.

PASADENA

HORTUS
284 E. Orange Grove Boulevard
Superbly selected perennials, antique roses, and a full nursery. Handsome collection of antique garden ornaments.

SAN ANSELMO

MODERN i 1950
500 Red Hill Avenue
Steven Cabella is passionate about modernism and time-warp mid-century (1935–65) furnishings. Vintage furnishings, Eames chairs, furniture by architects, objects, and artwork. Located in a restored modernist architect's office building.

SAN RAFAEL

MANDERLEY
By appointment: 415-472-6166.
Ronnie Wells' one-of-a-kind silk shams, antique fabrics, and vintage pillows set trends.

ST. HELENA

BALE MILL DESIGN
3431 North St. Helena Highway
Decorative and practical updated classic furniture in a wide range of styles. A favorite with decorators. Ira Yaeger paintings.

CALLA LILY
1222 Main Street
Elegant European luxury bed linens, accessories, frames.

SHOWPLACE NORTH
1350 Main Street
(Also in Santa Rosa and Carmel)
Interior design, fabrics, custom furniture.

ST. HELENA ST. HELENA ANTIQUES
1231 Main Street
(Yes, the name is intentionally repetitious.) Rustic furniture, vintage wine paraphernalia, vintage accessories.

TANTAU
1220 Adams Street
Charming atmosphere. Decorative accessories, furniture, hand-painted furniture, gifts.

TESORO
649 Main Street
Fresh-flower heaven. Topiaries, wreaths – vases, too.

TIVOLI
1432 Main Street
Tom Scheibal and partners have created a sunny indoor/outdoor garden furniture and accessories store. Tables and chairs and occasional pieces in iron, aluminum, concrete, and recycled redwood. Antique garden ornaments.

VANDERBILT & CO
1429 Main Street
(Also at the Stanford Shopping Center)
Extensive collections of luxury bed linens, books, glassware, hand-painted Italian ceramics, accessories. A year-round favorite in the wine country.

SANTA MONICA

THOMAS CALLAWAY BENCHWORKS, INC.
2929 Nebraska Avenue
By appointment: 310-828-9379.
Interior designer/actor Thomas Callaway designs, makes and offers custom-made star-quality arm chairs, sofas, and ottomans with deep-down comfort and timeless glamour. These are future heirlooms, very collectible.

HENNESSY & INGALLS
1254 Third Street, Promenade
Architects and designers flock to this book store, which specializes in the widest range of architectural books.

IRELAND-PAYS
2428 Main Street
Producer Kathryn Ireland and actress Amanda Pays (*Max Headroom*) created *le style anglais* for Anglophile Angelenos. Special pillows.

JASPER
1454 Fifth Street
Interior designer Michael Smith's brilliant store and atelier. In a cool, sleek former art gallery, this high-ceilinged studio displays bold vignettes of chairs, antiques from around the world, linens, cashmeres, art glass, and Smith's own designs. Worth a detour.

LIEF MONTANA
1010 Montana Avenue
Clean-lined Scandinavian antiques with a light touch. Gustavian-style bedroom furniture.

ROOM WITH A VIEW
1600 Montana Avenue
Children's furnishings, and especially glamorous bed linens by the likes of Cocoon (silks), Bischoff, and Anichini.

SHABBY CHIC
1013 Montana Avenue
Yes, they still do great smooshy sofas, but they've also moved on to tailored upholstery and a new line of fabrics.

SANTA ROSA

RANDOLPH JOHNSON STUDIO
608 Fifth Street
Master craftsman/designer Randy Johnson makes dreamy furniture and accessories with superb detail in a wide range of styles. Draperies, painted finishes. Finest custom artistry.

SONOMA

SLOAN AND JONES
First Street West, on the square.
Ann Jones and Sheelagh Sloan run and stock this splendid antiques store. Set in a fine old corner building, it's the place for country porcelains, silverware, Asian vintage furniture, photography, linens, and table accessories.

STUDIO SONOMA
380 First Street West

Designer Robin Nelson offers beautifully edited home furnishings, paintings, slipcovers, lighting. Seasonal delights – including hammocks for summer, quilts for winter.

VENICE

BOUNTIFUL
1335 Abbott Kinney Boulevard

By appointment: 310-450-3620. Vintage Edwardian and Victorian painted furniture, lamps, old beds, quirky *objets*. This is a street and a neighborhood to explore.

FLEA MARKETS

Flea-market fans in Los Angeles head for Long Beach or Pasadena fleas. Old, small towns in California's hinterlands often surprise with inexpensive, quirky antiques. In dusty, cob-webbed shops you may find heirloom linens and laces, old brass beds, Victorian chairs, Lalique vases, botanical prints, and hand-bound books, rusty tools, tins, and old signs. These are the eccentricities that give rooms texture and individuality. As any serious style watcher will tell you, watch for newspaper listings of auctions, antiques sales, estate sales, weekend flea markets, and seasonal vintage and antique furniture shows.

MAIL-ORDER

The following national specialty catalogues offer the best mail-order bedroom accoutrements – beds (basic and beautiful), luxurious and basic linens, mattresses, duvets, bedroom carpets, and custom-made pillows and bedcovers. From these outstanding catalogues, it would be tempting to outfit a palace – or a cozy cabin in the woods. Most catalogues include a selection of baby's and children's bed linens and bedroom furniture. One bed linens extra to recommend: free monogramming.

BERGDORF GOODMAN
**P.O. BOX 660598
Dallas, TX 75266
800-964-8619**

Pampering – with silken duvets fluffed with silk floss, silk and Merino wool blankets, Frette's best sheets, and heirloom trousseau linens. Very luxurious.

BLOOMINGDALE'S
**(Stores around the country)
800-777-0000**

Seasonal catalogues sell a broad swathe of housewares – from fine basic linens and pillows to substantial furniture. This is one catalogue that is not afraid to go a little over the top, offering very frou-frou bed linens, quilted silk bedcovers, and guilty-pleasure accessories along with the solid basic linens, towels, and pillows every home needs.

E. BRAUN
**717 Madison Avenue
New York, NY
212-838-0650**

These are the fine traditional bed linens of the Upper East Side in Manhattan that brides dream of for their boudoirs. Lace-trimmed sheets, exquisitely detailed silk bedcovers, beautiful hand-embroidered pillowcases. The quality of bed dressing here is seldom encountered today. Delicate bobbin laces, hand-sewn silk floss-quilted charmeuse throws, pure linens with grand monogramming, and silky mohair blankets are just the beginning. These are linens selected with utmost admiration for fine crafting – meant to last a lifetime.

CALICO CORNERS
**203 Gale Lane
Kennett Square, PA 19348
800-213-6366**

Ralph Lauren classic fabrics, along with ready-made bedding and accessories.

CHAMBERS
**P.O. Box 7841
San Francisco, CA 94120
800-334-9790**

Superb seasonal selections of fine European- and American-made bed linens, alpaca and silk blankets, cashmere bedcovers, bedroom furniture, floor cover-

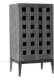

ings, and toiletries. The kind of catalogue to be read – in bed! Selections of linens are carefully considered and strike the perfect balance between elegance and freshness. But it's not all ruffles and pastels. Men, too, are taken care of beautifully with Prince of Wales checked sheets, no-nonsense bedroom rugs, and towels in colors such as mid-blue, tobacco brown, and Navy blue. Lamps, armoires, dressers, ottomans, and footstools are all well made and possess a certain charm.

COMING HOME
**I Lands' End Lane
Dodgeville, WI 53595
800-345-3696**

Well-priced bed basics, plus lots of goosedown comforters in a range of styles. Natural cotton sheets, blankets, towels. It's difficult to imagine that one would not find one's heart's desire in this encyclopedic catalogue. There are endless variations on the duvet – from simple and sufficient to giddily over-the-top. This catalogue not only offers undyed and pure finish linens, it also addresses children's and babies' needs. Look for seasonal sales and discontinued linens at excellent prices.

THE COMPANY STORE
500 Company Store Road
La Crosse WI 54601
800-285-3696
Broad choice of dependable bed linens, and every possible permutation of down comforters. Bedroom accessories, draperies, and window hardware. This reliable company will also custom-make shams, pillows, and bedcovers, or repair and refresh pillows and comforters.

CUDDLEDOWN OF MAINE
312 Canco Road
Portland, ME 04103
888-323-6793
De luxe European linens of the highest quality. Down comforters in four different warmth levels, pillows, towels, high-thread-count sheets. The catalogue is very inspiring. The proprietors are clearly devoted to the highest standards of bedding and have perfected the design of duvets. The selection is not enormous and convoluted, but offers the best possible bedding.

GARNET HILL
Box 262 Main Street
Franconia, NH 03580
800-622-6216
Originally, this catalogue offered only the coziest, thickest English cotton flannel sheets – and natural-fiber bed linens and sleepwear. They've branched out to bedroom draperies, dressers, classic fifties-style chairs, timeless bed styles, rugs, trundle beds, European bedroom slippers, bedside tables, blankets.

HOLD EVERYTHING
Mail Order Department
P.O. Box 7807
San Francisco, CA 94120
800-421-2264
Excellent source of storage – from hat boxes to underbed blanket boxes, to closet fixtures and fittings. Cedar chests, shoe boxes, bookcases, television cabinets.

HORCHOW
The Fine Linen Collection
P.O. Box 620048
Dallas, TX 75262
800-456-7000
Patterns with verve, colors that cheer. Best service: Supercale Plus cotton/poly percale in a choice of 20 colors – plus ginghams. Coordinated beds, plus basics.

MACY'S
P.O. Box 7888
San Francisco, CA 94120
800-622-9748
Excellent seasonal sales. Wide range of bedroom furniture, mattresses, pillows. Best-quality store-brand bed linens. Their's is an excellent catalogue for those who love Calvin Klein Home collections (chic and under-

stated) or for fans of Ralph Lauren's Home collections (which tend more to theme design and elaborate patterns).

THE NATURAL BEDROOM
P.O. Box 3071
Santa Rosa, CA 95402
800-365-6563
Natural-fiber, untreated, unbleached cottons, with Sonoma County wool stuffing, along with hand-tufted wool mattress toppers, and wool mattress pads. Elegantly simple maple bedroom furniture, plus natural linen sheets, paisley cotton damask untreated cotton sheets, pillowcases.

NEIMAN MARCUS BY MAIL
Fine Linens
P.O. Box 650589
Dallas, TX 75265
800-825-8000
Great luxuries, including Ralph Lauren's White Label Collection (590 thread-count Egyptian linens), cashmere throws, Ann Gish silk bed dressing, along with Italian linens. Great basics.

POTTERY BARN
P.O. Box 7044
San Francisco, CA 94120
800-922-5507
Well-priced and well-made furniture and accessories. Seasonal selections of sheets, throws, rugs, vases, and now paint. Decorative draperies and window hardware. Perhaps best of all, Pottery Barn is now developing its own products. Their sheets

and bedcovers look individual and timeless, but avoid faddishness. Beds also transcend the usual cliches with simple Modernist styles for city apartments, along with more massive wood headboards for larger country bedrooms. Smaller items may be returned to the nearest Pottery Barn store, which saves the cost of shipping.

CATALOGUE PHOTOGRAPHS
California design showcase: Photographed in this catalogue are new designs from the following collections: McGuire (Orlando Diaz-Azcuy), Baker Furniture (Barbara Barry and Michael Vanderbyl), Michael Berman Collection, Mike Furniture (Michael Moore).

A

Accessories, 103-4

Antiques, 37, 38, 54, 116

Architectural details, 62

Armchairs, 54, 94

B

Barry, Barbara, 7, 9, 11, 49, 52, 80

Bartlett, Thomas, 35

Beds, 65-66.
See also Mattresses; Sheets
 canopies, 42
 children's, 99
 construction, 66
 daybeds, 65, 94
 dressing, 41
 footboards, 54
 fourposter, 42, 65
 headboards, 66
 height, 65
 metal, 65-66
 positioning, 83

Benches, 54

Berman, Michael, 17, 107

Biederbeck, Doug, 68

Bonauro, Tom, 45

Books, 52

Brady, Stephen, 75, 76, 93-94

C

Candles, 53, 73

Carpets, 46, 49-50

Ceilings, 33

Children's bedrooms, 97-99

Color schemes, 54, 79-80

Colvin, Barbara, 80

D

Daybeds, 65, 94

Deitz, Melissa Wallace, 27, 108

Design philosophies, 35-38

Diaz-Azcuy, Orlando, 42

Draperies, 45, 54

Dunnaway, Sutta, 45

Dunsford, Laura, 66, 101

Durkin, Douglas, 60

Duté, Michael, 104

Duvets, 75-76

E

Erb, Alice, 87, 112

F

Fabrics, 62, 89

Feng Shui, 83-84

Fireplaces, 33, 53

Flea markets, 87, 89, 116

Floors, 42, 46, 49-50

Flowers, 53

Floyd, Linda, 35-36

Futons, 68

G

Gertz, Jamie, 19

Gilliam, Peter, 79

Guest rooms, 93-94

H

Hoefer, Wade and Myra, 7, 113

Home offices, 50, 52

Huntzinger, Brad, 9, 21

Hutton, Gary, 35, 38, 45, 65

J

Jennings, Jim, 65

Jones, Ann, 36, 115

Joyce, Kerry, 9, 19, 57

Junk shops, 87, 89

K

Kase, Arnelle, 29, 103

Keenan, Emily, 79

L

Landenburger, Brett, 94

Lighting, 33, 42, 49, 73, 94, 99

Livingston, David, 87

M

Mattresses, 68

McIntyre, Kate, 9, 21

Meskan, Joszi, 9

Mirrors, 62, 83, 94

Moscow, Elinor, 91, 104

O

Ottomans, 54

P

Paint, 41, 89

Phipps, Dan, 33

Pilaroscia, Jill, 79, 80

Pillows, 53, 75

Plants, 83

Q

Quilts, 54

R

Remodeling/renovating tips, 33

Romance, 42, 53

Ross, Liz, 104

S

Saladino, John, 35

Sant, Michael, 83

Scheibal, Tom and Linda, 36

Scott, Candra, 52

Shansby, O.J. and Gary, 31

Sheets, 53, 71-72

Shubel, Stephen, 9, 15, 33, 41, 62, 76

Slavin, Sara, 104

Small rooms, 59-60, 62

Smith, Michael, 7, 9, 13, 115

Stamps, Kate, 7, 25, 52

Stamps, Odom, 25

Stereo systems, 53, 54

Storage, 45-46, 94, 99

Straley, Jonathan, 38, 50

T

Tables, 41, 49

Tedrick, Michael, 35, 38, 52, 54, 59

Telephones, 53

Televisions, 52, 94

Thompson-Kennedy, Jody, 104

Throws, 54

Trends, avoiding, 35

V

Van Runkle, Theadora, 42

Virtue, Andrew, 9, 23, 60, 107

W

Wade, Patrick, 76

Walker, Troy, 50

Waterman, Scott, 94

Windows, 33, 41–42, 54, 94

Grey Crawford
11, 38, 41, 48, 51, 63, 79, 81, 82, 94, 101

Philip Cruz
61

Mark Darley
12, 30

Scott Frances
35

David Livingston
3, 8, 20, 21, 36, 39, 58, 59, 65, 66, 83, 85, 86, 96

Colin McRae
44, 46, 70, 73, 90, 99, 102

Jeremy Samuelson
14, 16, 26, 27

Ron Starr
97

Tim Street-Porter
10, 22, 52, 60, 72

John Vaughan
50, 55

Dominique Vorillon
18, 57, 84

David Wakely
49, 56

Alan Weintraub
1, 6, 24, 25, 28, 29, 32, 34, 37, 40, 42, 43, 45, 47, 53, 62, 64, 67, 69, 74, 76, 77, 78, 80, 87, 88, 91, 92, 93, 95, 98, 100, 103, 104, 105, 120

A C K N O W L E D G M E N T S

It has been my great joy to work on this book.

Madeleine Corson's graphic design made my text and concepts sing. Heartfelt thanks.

I have had the pleasure of working with highly professional and creative photographers and interior designers
who contributed their considerable talents to make this book beautiful and inspirational.

I am especially grateful to California photographers Tim Street-Porter, Alan Weintraub, Grey Crawford,
Jeremy Samuelson, Mark Darley, Colin McRae, David Livingston, Dominique Vorillon, and Michael Bruk.

Designers and architects with whom I have had the pleasure to work include Michael Berman,
Barbara Barry, Michael Smith, Paul Wiseman, Douglas Durkin, Ann Jones, Suzanne Tucker, Gary Hutton,
Mike Moore, Andrew Virtue, Stephen Brady, Michael Tedrick, Arnelle Kase, Orlando Diaz-Azcuy,
Kate-and Odom Stamps, Raun Thorp and Brian Tichenor, Kerry Joyce, Joszi Meskan, Stephen Shubel,
Kate McIntyre and Brad Huntzinger, and Myra Hoefer. Others who have contributed their expertise
include Lauren Berger, Jill Pilaroscia, Melissa Deitz, and Theadora Van Runkle.

Terry Ryan is my superb editor.

Bouquets to my special friends at Chronicle Books — Editor-in-Chief Nion McEvoy,
Sarah McFall Bailey and her helpful staff, Christina Wilson, Pamela Geismar,
Dean Burrell, and Christine Carswell.

Heartfelt thanks.
Diane Dorrans Saeks

༺༻

A U T H O R

Diane Dorrans Saeks is a writer, editor, and lecturer who specializes
in interior design, architecture, gardens, travel, and fashion. She is the California editor
for *Metropolitan Home,* a contributing editor for *Garden Design,* San Francisco correspondent
for *W* and *Women's Wear Daily,* and a frequent contributor to the *San Francisco Chronicle.*
Her articles have appeared in magazines and newspapers around the world, including *Vogue Living,*
Vogue Australia, In Style, the *New York Times,* the *Washington Post,* the *Los Angeles Times,*
the *London Times,* and the *Sydney Morning Herald.* Her previous books include *California Wine Country,*
California Cottages, San Francisco Interiors, San Francisco: A Certain Style, California Country,
California Design Library: Living Rooms, California Design Library: Kitchens, and *California Design
Library: Bathrooms,* all published by Chronicle Books. She lives in San Francisco.